New York

PHOTOGRAPHED BY GUILLAUME GAUDET

The sun has been up for an hour and already cycle commuters are pedalling across Brooklyn Bridge's iconic suspended span over the East River to begin their working day in Manhattan. From the bridge's boardwalk you can spy five other bridges and, in the distance, the Statue of Liberty welcoming 'huddled masses yearning to breathe free'. Manhattan's skyline, now with One World Trade Center ahead, never fails to thrill. You'll find photos of these iconic sights and more among these pages but this is a book about so much more than a tourism tick-list of New York City's highlights.

Our ambition was to chronicle a day in the life of this greatest of cities from the perspective of a photographer who knows and loves it. We wanted to present not just the famous sights but also New York's daily rhythms as a local would experience them. The book is loosely organised according to the passage of a day and night in the city: we start with a ferry trip in dawn's cool light, a coffee, and yoga at Bryant Park, and finish with a cocktail in a speakeasy-style bar then dancing in a nightclub. Along the way we follow the photographer on his peregrinations through New York's diverse neighbourhoods, exploring their signature experiences, from Wall St finance and Times Square's neon to skateparks, street art, neighbourhood basketball courts, delis and diners, and

New York's great galleries and museums. It would be impossible to capture all of New York City's incomparable variety but readers will discover its personality and personalities beyond the famous sights.

For a task of this scale, we sought a photographer for whom New York was more than just a home. Guillaume Gaudet – who lives in Queens and specialises in travel, portraiture, interiors, lifestyle and fashion photography – moved to New York in 2007 and fell in love with the city. 'This melting pot has become an inexhaustible source of inspiration for me,' he says. Helping Guillaume was writer Zora O'Neill, another Queens resident. Zora moved to New York in 1998, drawn by the city's energy and diversity. She has written for Lonely Planet since 2005, and she is the author of the travel memoir All Strangers Are Kin, about studying Arabic and travelling in the Middle East.

Between them, they photographed and described all these facets of New York life. The result is this chronologically-ordered visual odyssey through one of the world's great cities, a taste of New York that may give first-time visitors fresh ideas of what to see and do, and also inspire long-time lovers of the metropolis to make another trip to The Big Apple.

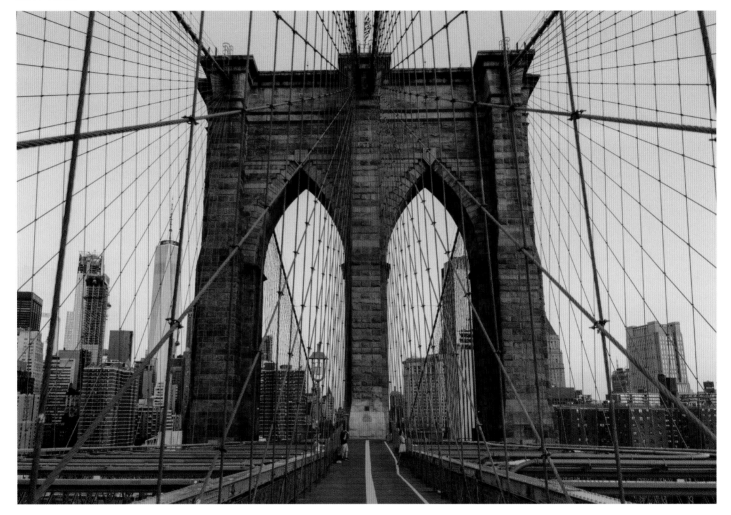

0600: 'M' is for Manhattan: the neo-Gothic arches of the Brooklyn Bridge, which was the world's longest suspension bridge when it was erected in 1883, form a kind of welcome sign to New York, as well as one of the city's most iconic skyline views. The bridge is now a National Historic Landmark.

'I shot this image in summer at 6am. As I live in Queens, I woke up at 4.30am to be able to have a coffee and a little breakfast before heading to the bridge. Going there at sunrise is the only way to get some photos without the crowd. Tourists arrive early and it gets packed pretty fast. In the background you can see a photographer shooting a model. He knows that you have to come very early to get the best light and a quiet environment.'

- *Guillaume Gaudet*

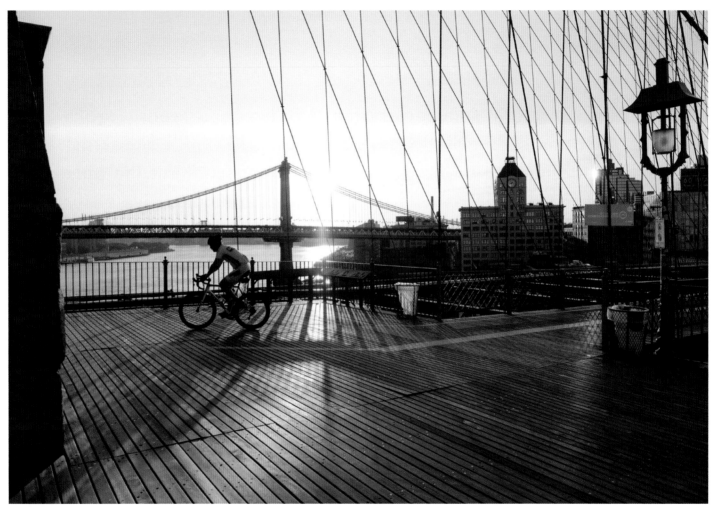

The Brooklyn Bridge forms a key link between the boroughs. Along with 100,000 or so cars, more than 4000 pedestrians and 2600 cyclists make use of the bridge every single day, via an old-fashioned boardwalk made of more than 11,000 hardwood planks, which are replaced every 35 years.

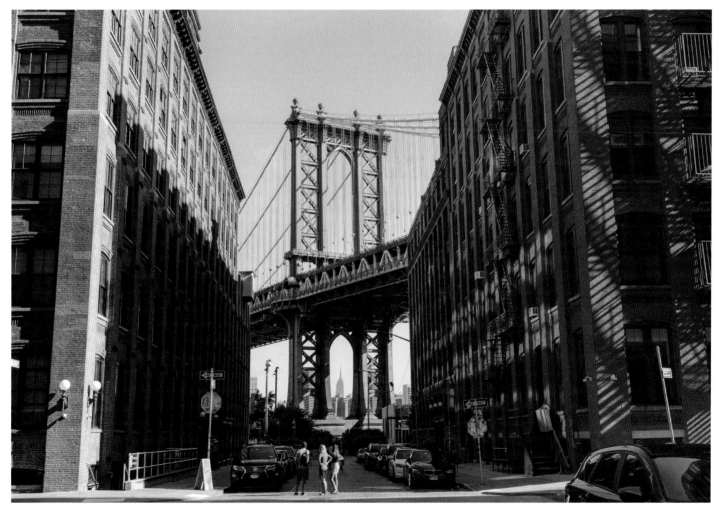

This is the view that inspired the nickname of the former warehouse district now known as Dumbo: Down Under the Manhattan Bridge Overpass. The industrial heritage has given way to film screenings, a seasonal pop-up swimming pool and a 'Shakespeare at Sunset' theatre season every summer.

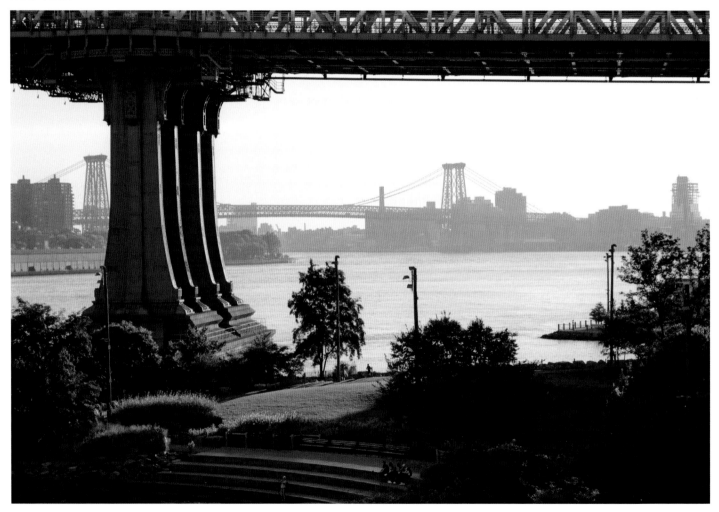

In Dumbo, the once-industrial waterfront has been remade as a ribbon of green park space, with up-close views of the piers of Manhattan Bridge. To link all the revived areas, a new ferry service was introduced in 2017, connecting piers in Queens and Brooklyn with Manhattan.

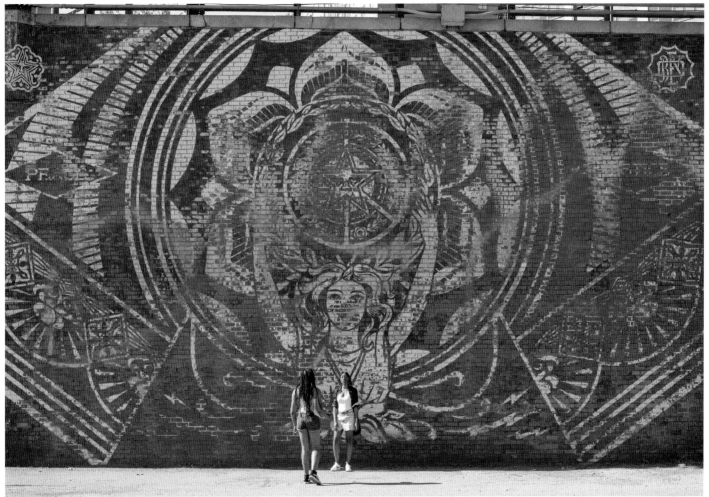

Dumbo's redbrick warehouse walls, once neglected, now make great workspace for street artists such as Shepard Fairey. More old-fashioned attractions include Jane's Carousel, a 1920s fairground ride complete with 48 beautifully painted wooden horses contained in a glass structure designed by architect Jean Nouvel.

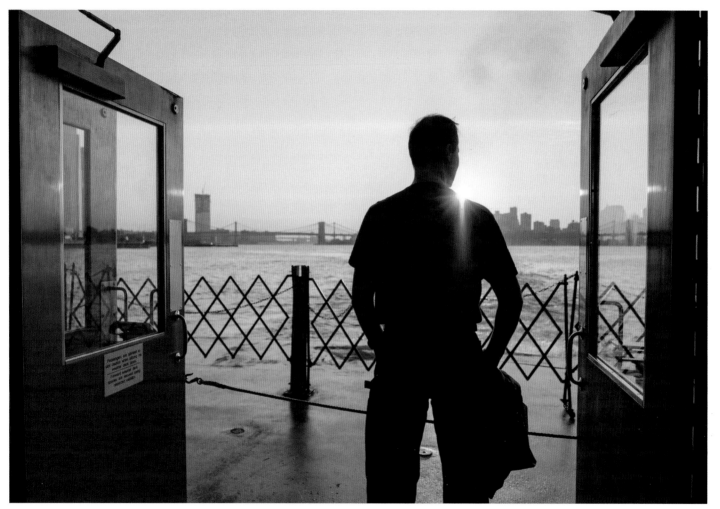

Staten Island is the only borough not connected to Manhattan by a bridge, so many residents make the commute by ferry. The payoff for a slight increase in transit hassle? Twenty-five peaceful minutes on the water, with dazzling views of lower Manhattan and the Statue of Liberty.

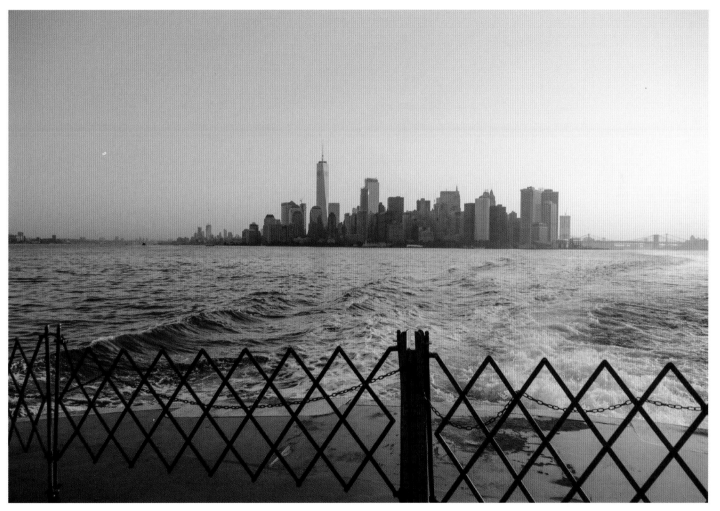

Since the city began operating the ferry in 1905, it has always been inexpensive, and after a few fare negotiations the price was reduced in 1997 to absolutely nothing. This free service is a boon for residents and one of the most popular sightseeing deals for visitors.

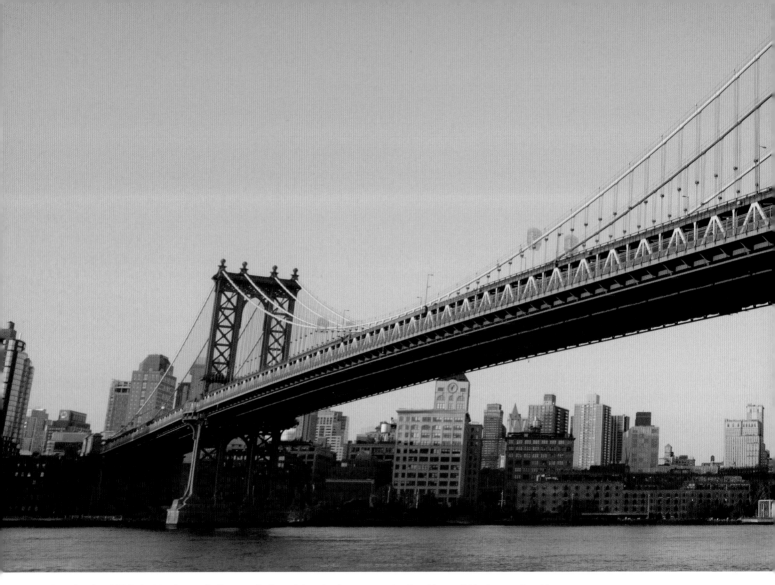

Completed in 1909, the Manhattan Bridge was the last of three bridges connecting Brooklyn and Manhattan. Brooklyn Bridge is to the south and Williamsburg Bridge to the north, creating a handy mnemonic for their order: BMW.

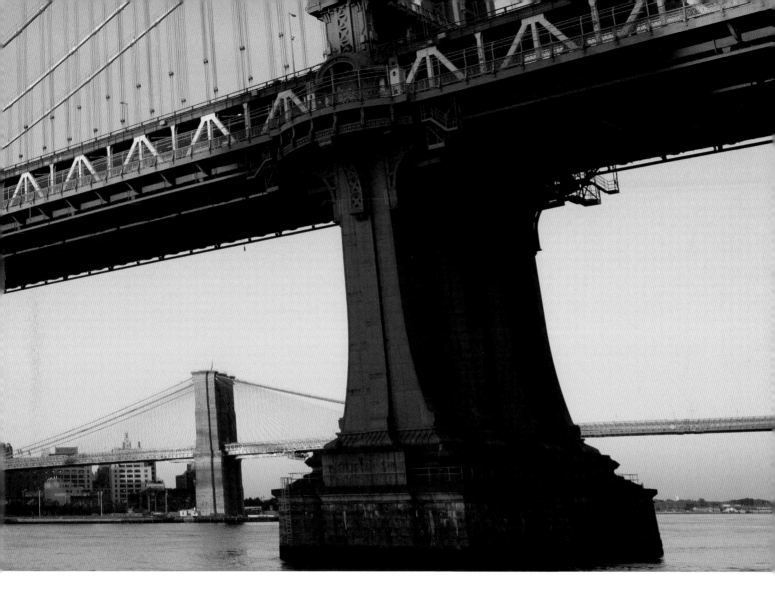

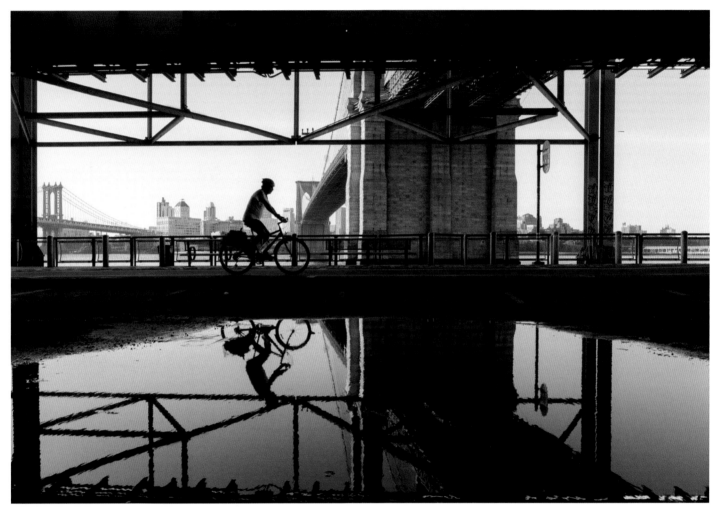

The East River Greenway runs along the water's edge, connecting with other paths to form a full 31 mile (50km) loop around the island of Manhattan. It's a mixed bag of good and bad, but among the former are views of the Chrysler Building and the Empire State Building, as well as the United Nations Plaza.

'This picture is a good example of my street photography style. It combines key factors: a New York background, a reflection (puddle or glass) and people, some life to create a story. When I see a big puddle, I always try to get something out of it. I can wait for half-an-hour before anything interesting happens but sometimes it's worth the wait. I shot this one around 6am on a Sunday but there were already runners, passersby and bikers on the East River Bikeway, so I didn't have to wait long for the shot.'

- Guillaume Gaudet

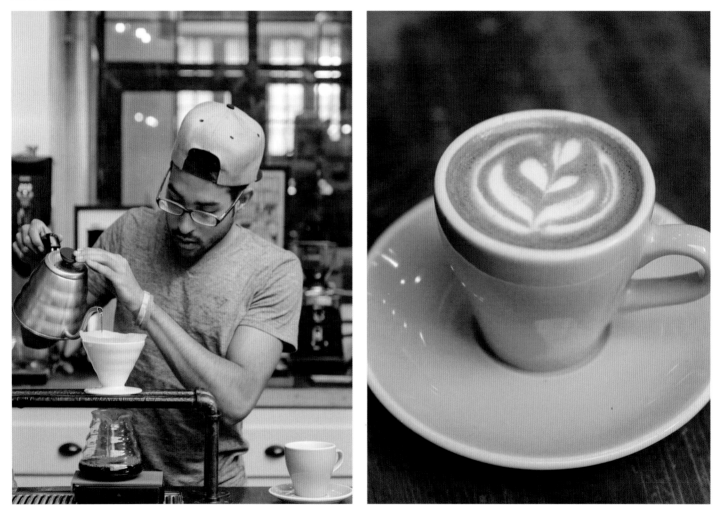

New Yorkers run on coffee, which is available in all varieties, from the humble street-cart paper cup to baristas' meticulous works of drinkable art (as seen here at Devocion in Williamsburg). Note: in old-school NYC parlance, a 'regular coffee' comes with milk and sugar.

Coffee shops and tea houses in hip neighbourhoods such as Williamsburg – which in 2013 had the city's highest concentration of caffeine outside Manhattan – often function as offices for some of the four million or so freelance workers in the NYC metropolitan area.

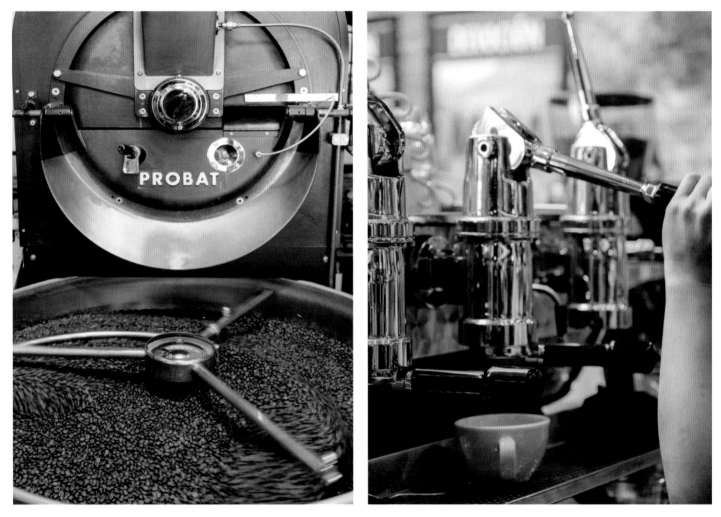

In 1927, an Italian immigrant, Domenico Parisi, brought the first espresso machine to New York, placing it proudly in his little six-table Caffe Reggio at 119 Macdougal St. Much later came Starbucks. Now the city is riding the 'third wave' of coffee innovation, which includes in-house roasting.

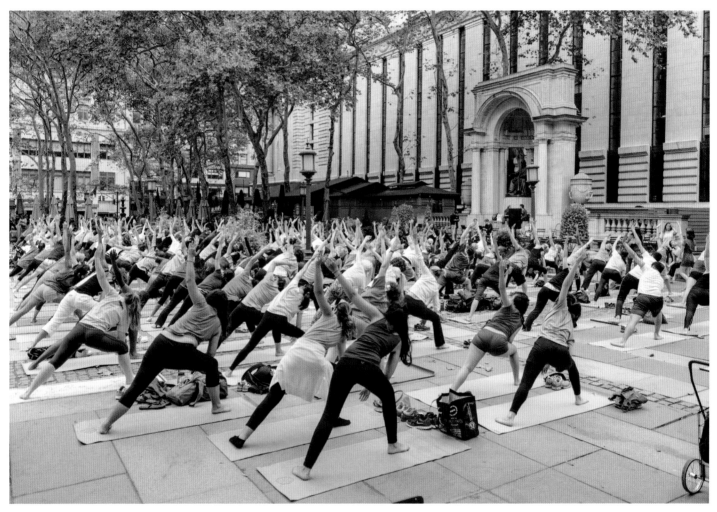

0800: Typical of its location smack in Midtown, Bryant Park is busy all day with diverse activities, from morning yoga and bootcamp sessions to evening screenings. In colder months the Winter Village offers the city's only free ice-skating rink. The rest of the year, office workers treat it as a kind of public backyard.

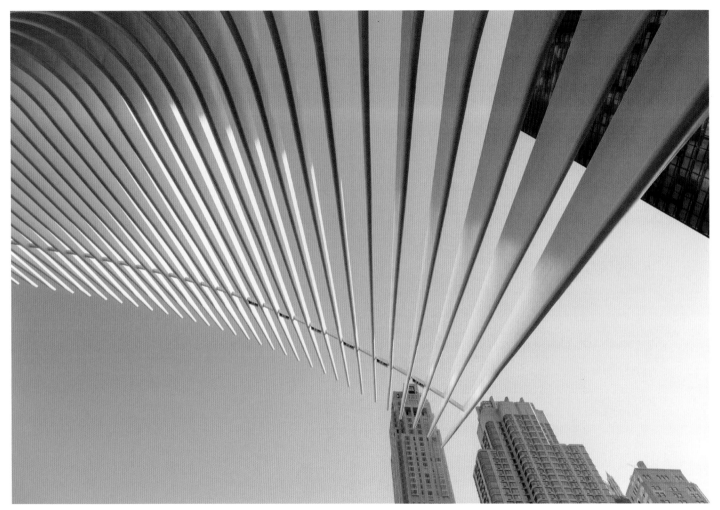

Subway lines and the PATH train from New Jersey converge at the World Trade Center Transportation Hub, which replaced a station destroyed in the 9/11 attacks. With more than a decade between commission and its 2016 opening, the hub suffered from significant redesigns, budget overruns and delays due to a leaky roof.

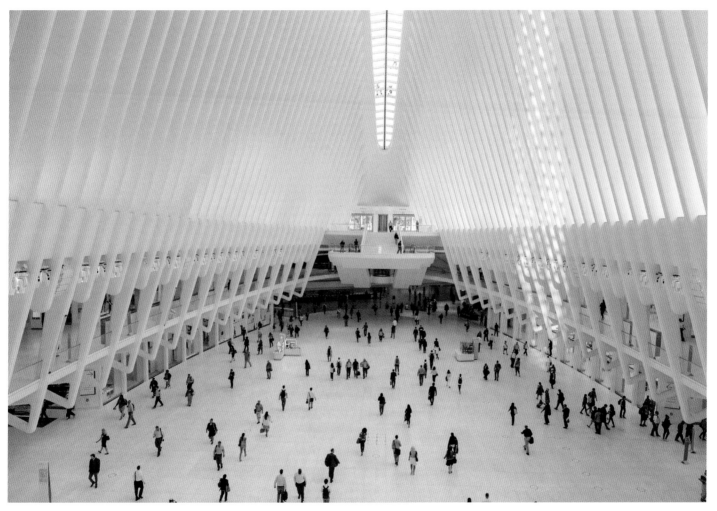

Although the architect of the World Trade Center Transportation Hub, Santiago Calatrava, envisioned a bird taking flight, one headline instead proclaimed it 'Stegosaurus rising'. As each PATH train arrives during rush hour, the station's light-filled central hall, the Oculus, fills with a fresh flood of commuters.

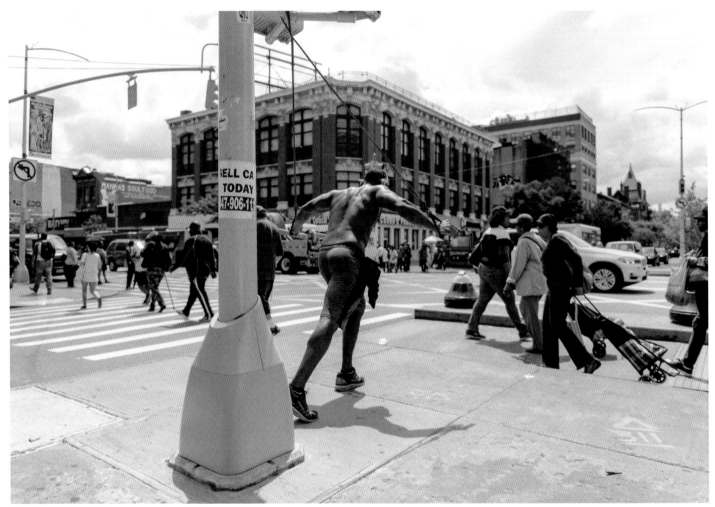

Dr Martin Luther King Jr Blvd (aka 125th St) is Harlem's main commercial avenue. It is a vibrant mixture of mom-and-pop shops, big-box stores, landmarks such as the Apollo Theater, street vendors selling shea butter and incense, and – as one Harlem resident here demonstrates – even an outdoor gym.

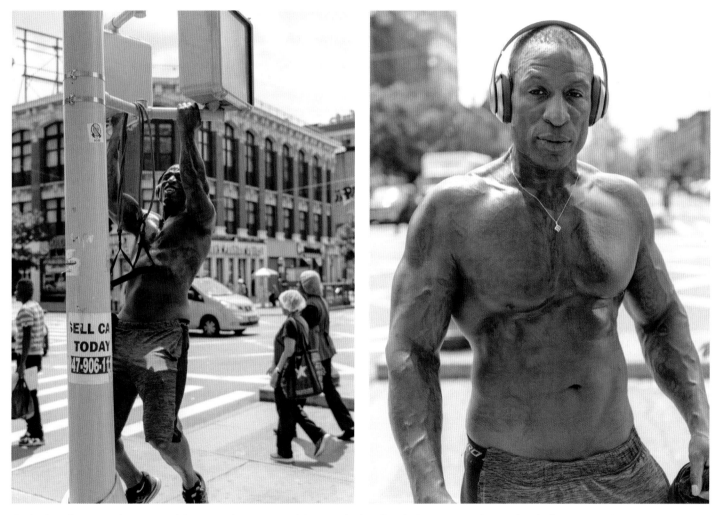

The boulevard is a natural extension of the city's subway stairs and fast-paced sidewalks, which – given Manhattan's length of 13 miles (21km) and its 12,750 miles (20,500km) of sidewalks – offer a natural workout and help to make it one of the healthiest counties in the state.

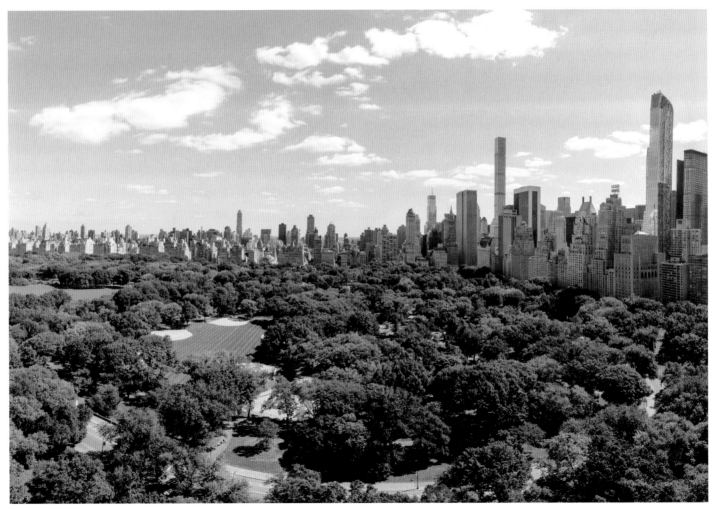

It consists of more than 800 verdant acres (324 hectares) right in the middle of Manhattan, but Central Park was hardly central when it was first laid out in 1858. Most of New York City was farther to the south, and later grew up around the park.

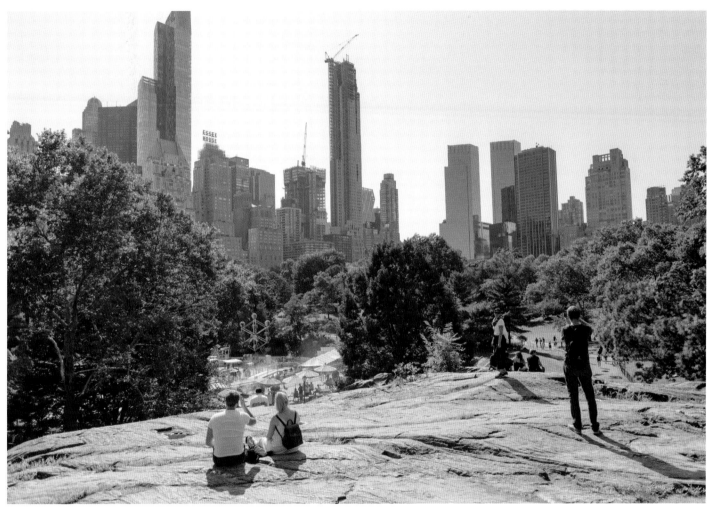

Apartments with Central Park views are coveted real estate, and a rash of new tower construction since 2000 has been controversial. Now more people have green views, but the new buildings cast shadows over the old ones, as well as the park itself.

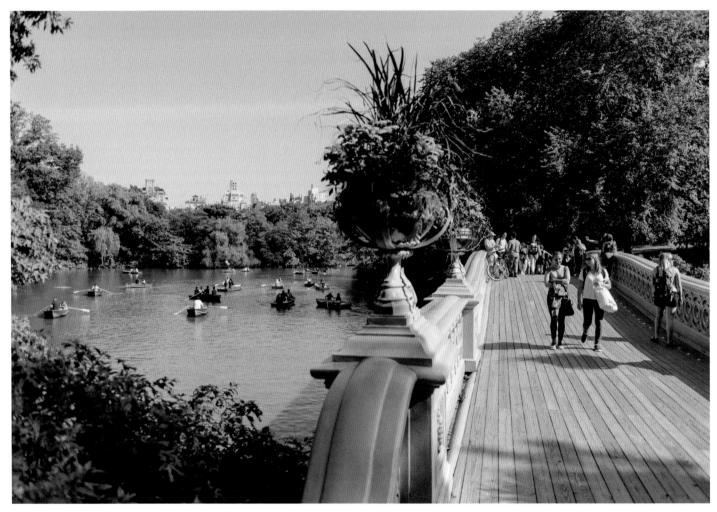

Landscape architect Calvert Vaux designed 36 bridges that crisscross Central Park. Each one is unique, constructed in different styles and types of stone and steel. The park is a mixture of patches that feel pretty wild and more groomed areas for public recreation.

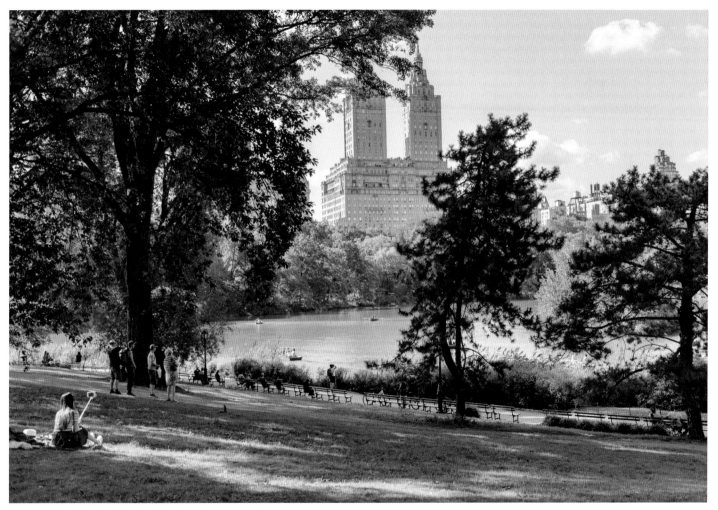

Frederick Law Olmsted and Calvert Vaux, the park planners, emphasised that it should be a 'democratic development', though only high flyers got the views from the likes of the 1930s San Remo apartment building, where famous residents have included Barry Manilow, Dustin Hoffman, Diane Keaton and Tiger Woods.

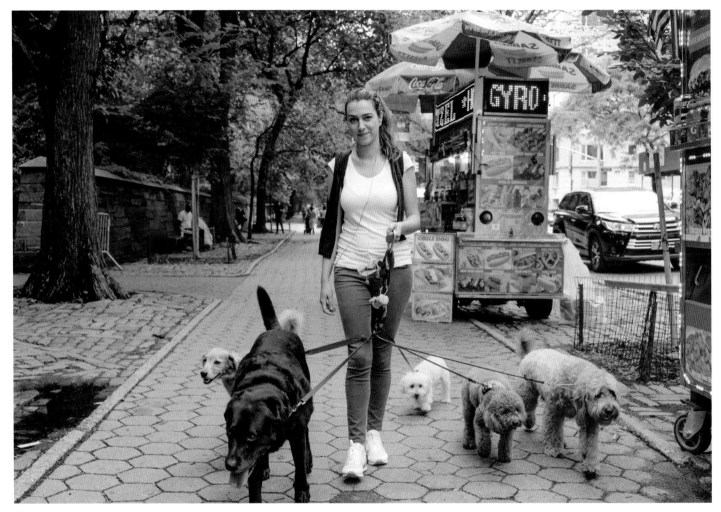

1000: Dog walking is a key city service. The luckiest pups get to stroll around Central Park. An average New Yorker works 49 hours a week, so outsourcing pet care is necessary for most. And with more than 30,000 licensed pooches in Manhattan alone, they often get to make lots of friends on their walks in the park.

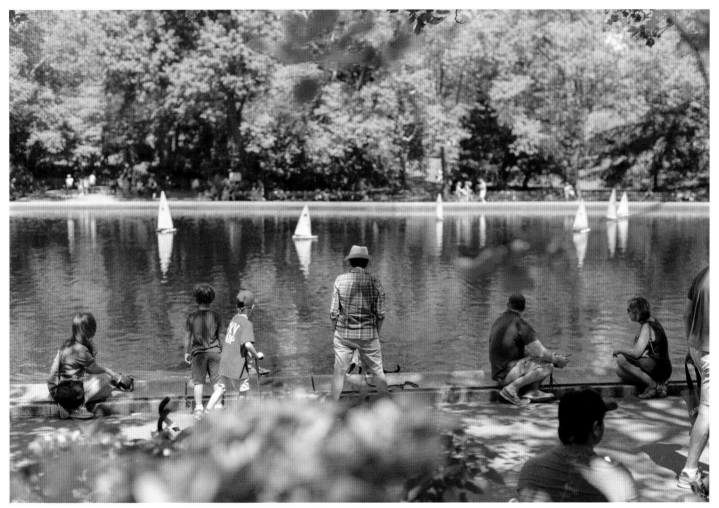

Central Park's Conservatory Water, midway up the park on the east side, has been home to miniature sailboat races for more than 140 years. Using remote-controlled boats, kids can learn the basics of sailing without getting wet. The Central Park Model Yacht Club holds a race every Saturday morning.

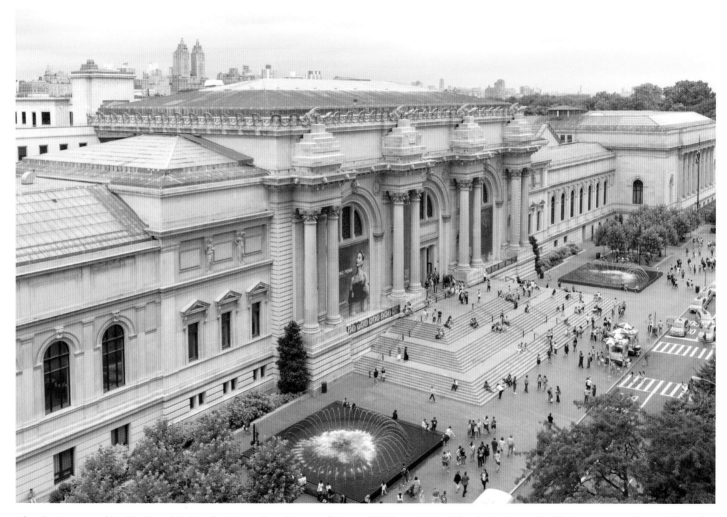

After the city granted land in Central Park to the Metropolitan Museum of Art, an 1893 law stipulated that the institution 'shall be kept open and accessible to the public free of charge throughout the year'. Admission to the museum is now a suggested donation.

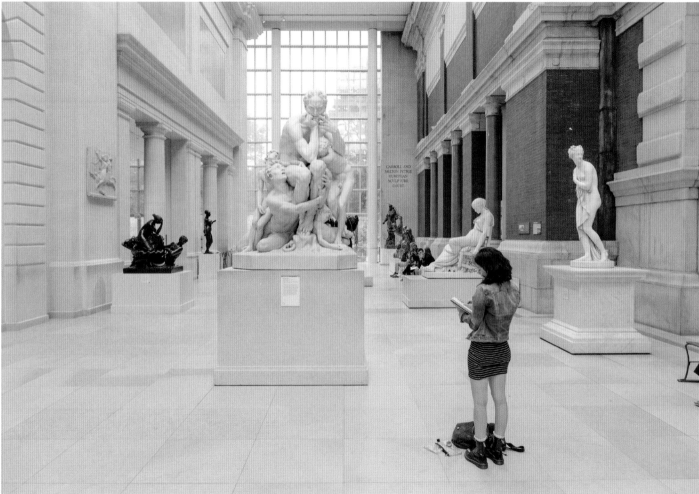

The Met's collection is a great resource for the city's art students, who can inspect every subtle detail in works such as Carpeaux's neoclassical *Ugolino and His Sons* and, in nearby halls, compare it with classical Greek and Roman sculpture.

The Metropolitan Museum of Art owns nearly half a million works, though only 10% of them are on view at any given time. The diversity of holdings, from ancient to contemporary and drawn from all over the world, make them a great resource for the city's art students and a treat for the seven million people who visit annually.

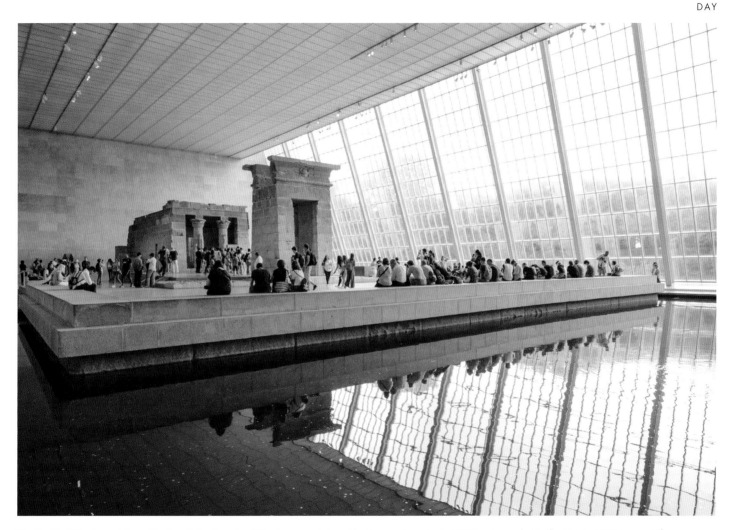

The Sackler Wing's most dramatic piece is the Temple of Dendur, commissioned by Caesar Augustus in 10BC and awarded to the Met in 1967 to save it from flooding by the Aswan High Dam. Architects Kevin Roche John Dinkeloo and Associates designed a space evoking its original location on a hillside near the Nile.

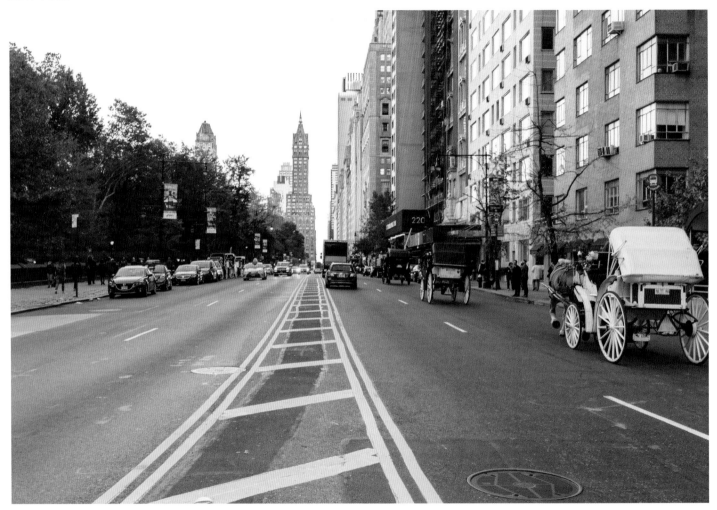

1100: Carriage horses 'commute' to work in Central Park via 59th St from four stables on the far west side. Early in the morning and late in the evening they're a normal part of traffic. The horses enjoy workers' rights, including set working hours, periodic veterinary checkups and five weeks' vacation each year.

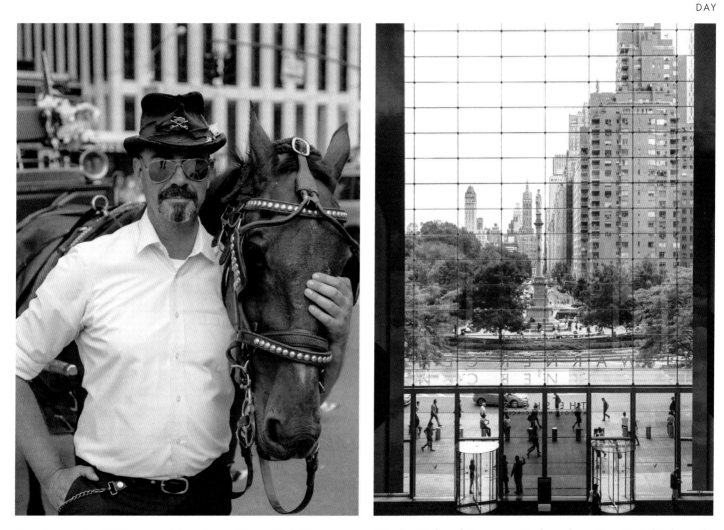

Currently more than 200 horses work in and around Central Park. Want to befriend one? Carriage drivers recommend carrots as the best treat.

Columbus Circle, with its monument to the explorer, sits on Central Park's southeast corner. The white noise of the fountain drowns out the sound of traffic.

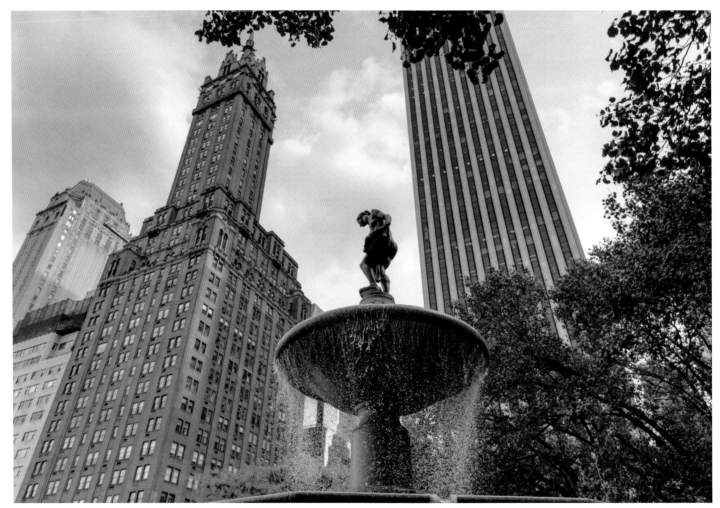

The Fifth Avenue shopping district runs south from 59th St, at the corner of Central Park. The Pulitzer Fountain – commissioned by Joseph of publishing's Pulitzer Prize fame – depicts Pomona, the goddess of abundance; fitting for the luxury shops and apartments in the area.

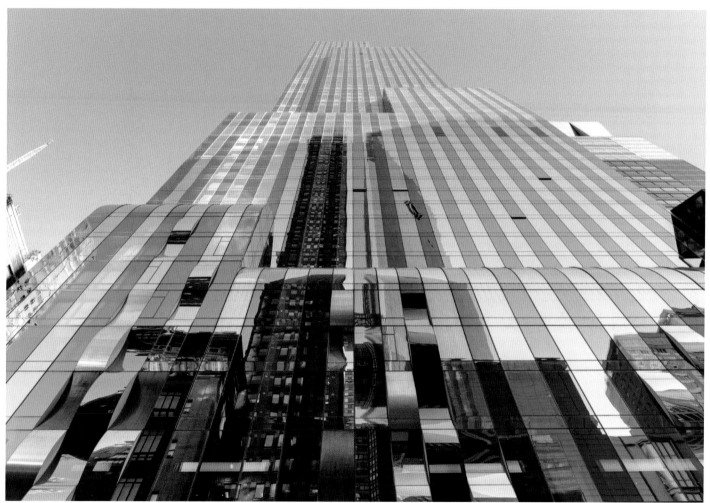

Designed by French architect Christian de Portzamparc, the 1005ft-high (306m) One57, at Seventh Ave and 57th St, was briefly the tallest residential building in Manhattan. Together with the newer, 1396ft-tall (425m) 432 Park Avenue, it represents a new phase of much-criticised super-towers in the city.

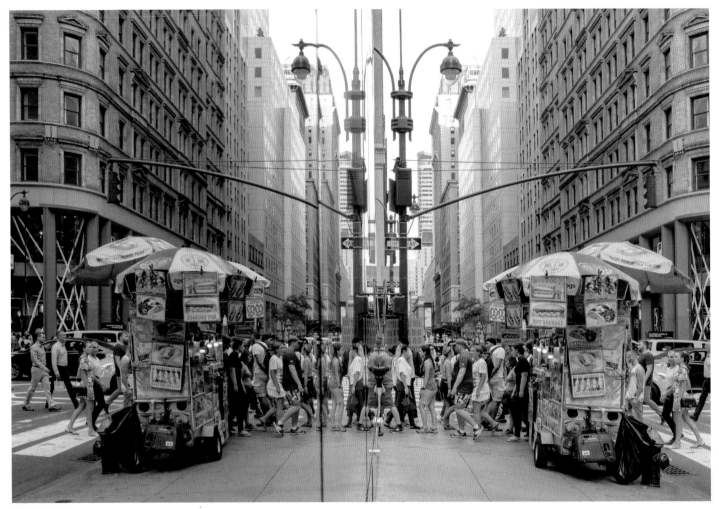

Fifth Ave forms a frequent route for parades – although there's no need to wait for a holiday to see a huge amount of foot traffic, as the four million commuters who venture into Manhattan every day are joined by 60 million tourists each year.

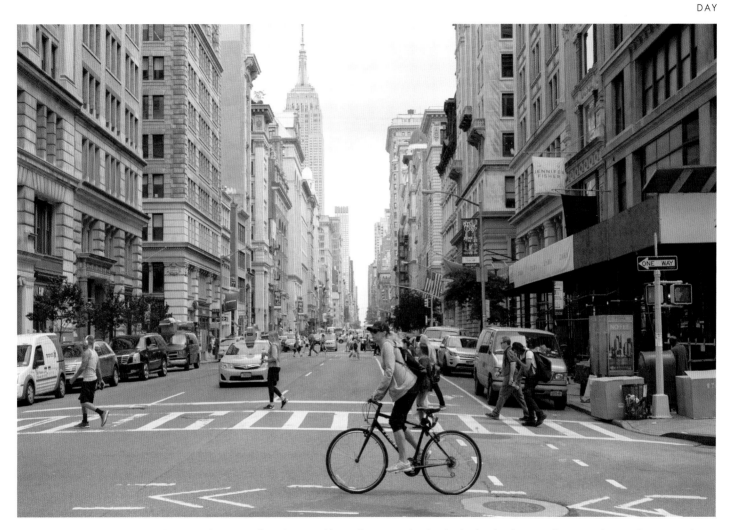

Running for 6.2 miles (10km) roughly down the centre of Manhattan, Fifth Ave (here at 18th St) is the dividing line between the east and west sides, a critical distinction when navigating. Every transplanted New Yorker has a story about overlooking the 'E' or 'W' in a Manhattan street address.

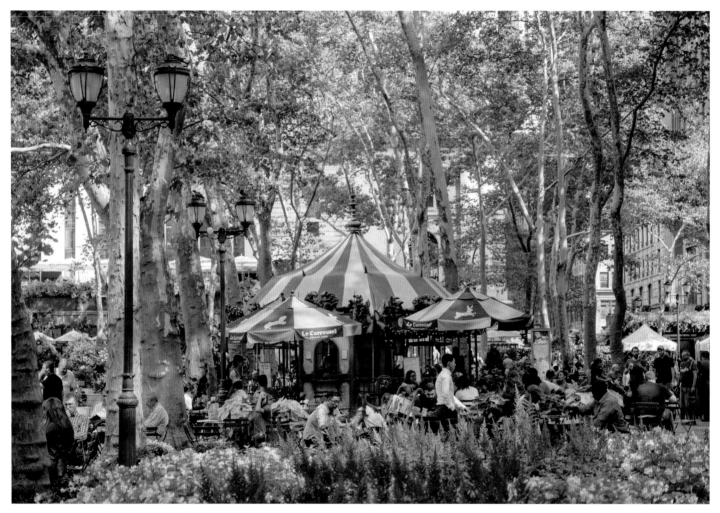

At 42nd St, Bryant Park is busy year-round. Its Le Carrousel was built to match the French classical style of the landscaping. With 14 traditional carousel animals revolving to French cabaret music, it's a firm favourite in the park, not least because it was built by the Brooklyn-based Fabricon Carousel Company.

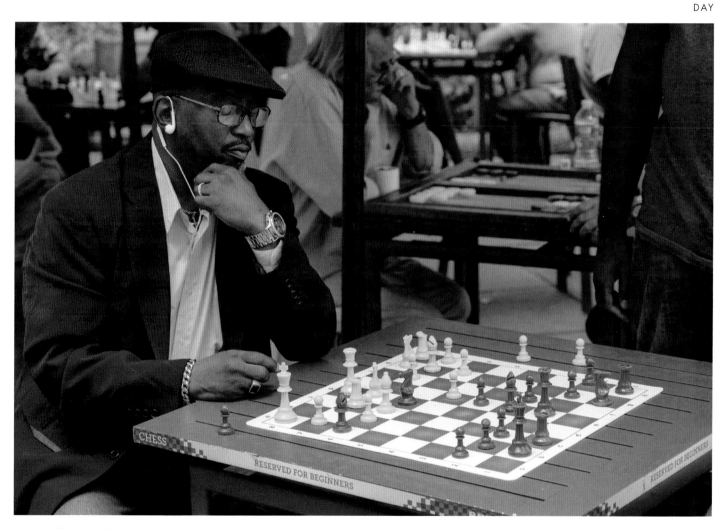

Bryant Park's chess tables are one of several public places around the city to match strategy against a stranger. Other favourite places to master the King's Indian Defence include Washington Square Park, the corner of Manhattan's chess district and close to its oldest chess store, the Village Chess Shop on Thompson St.

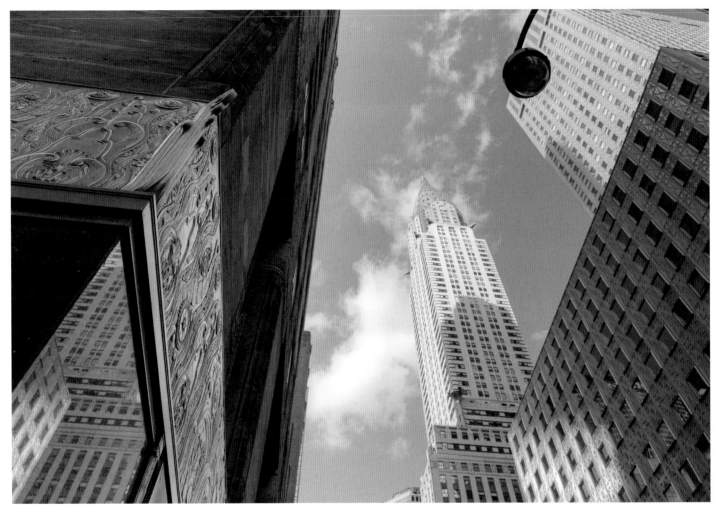

In its race against the Empire State Building to be the world's tallest, the Chrysler Building grew at a rate of four floors per week. And although the ESB did surpass it in the end, the Art Deco Chrysler, designed by William Van Alen, often rates higher on polls of New Yorkers' favourite piece of city architecture.

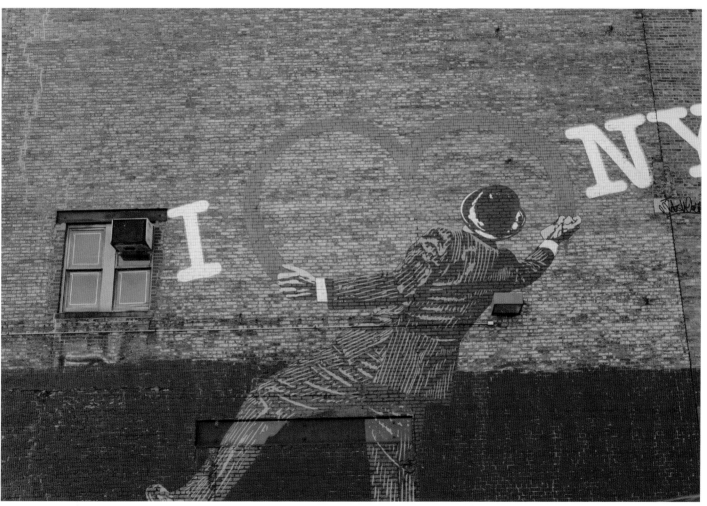

Bristol-born British street artist Nick Walker has mounted several versions of this artwork around the city. This one decorates a parking lot in Chelsea. Milton Glaser's 'I ♥ NY' slogan was originally developed as part of a tourism campaign for New York State. After 9/11, it became more associated with NYC.

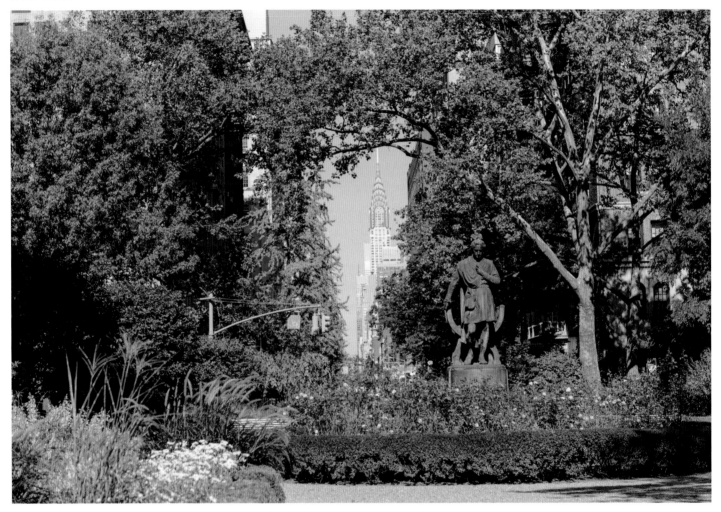

Gramercy Park, near Union Square, is the only private park in Manhattan. Only residents of surrounding buildings have keys (and guests at the hotel on the corner can be escorted there for an hour). The park opens to the public on Christmas Eve for one hour of carol singing with the Parish of Calvary-St George's.

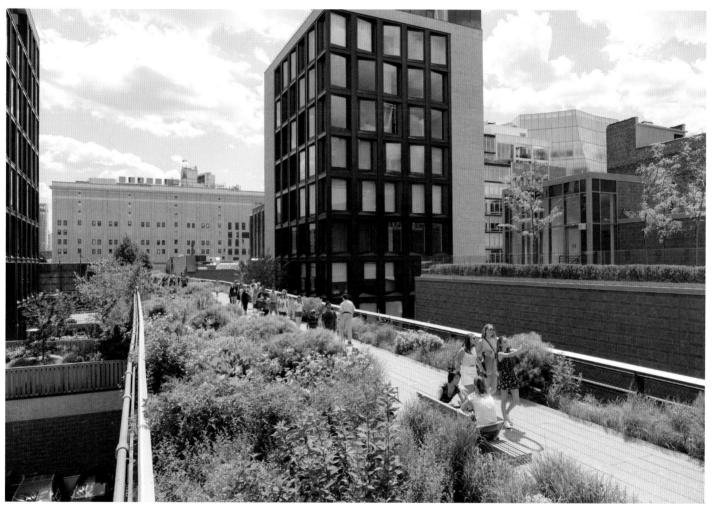

Chelsea's High Line park, built on 1.45 miles (2.3km) of abandoned elevated rail track, remade Manhattan's far west side. It has proved so popular since its 2009 opening that you can even buy souvenirs (we favour the socks). Its landscaping uses many of the weeds and wildflowers that were growing there before renovation.

In Midtown, a woman sports typical New York City street style: deceptively casual and ready for walking.

Bad weather – and there's a lot of it, whatever the time of year – never puts a stop to the city's fast-paced street life.

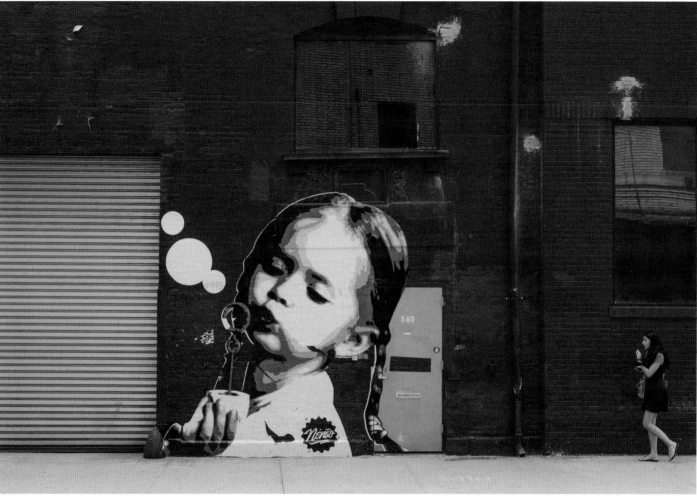

Artwork by Gustavo Nénão

Brazilian Gustavo Nénão's black-and-white style adorns a warehouse front. Elsewhere in the district, an 80ft-tall (24m) child by Os Gemeos overlooks a school playground, British artist Phlegm's birdlike figures hunch near a playground/community garden, and Jordan Betten's High Line Zoo animals converge on a rooftop.

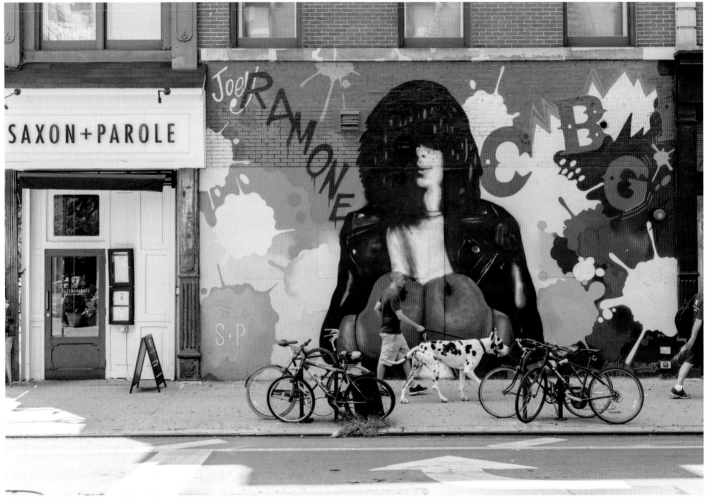

Joey Ramone / CBGB Tribute by CRASH & Solus, commissioned in 2015 by L.I.S.A Project NYC.org

At the corner of Bleecker and Bowery, CBGB was a club named (and intended) for country, bluegrass and blues. But it soon became the centre of NYC's punk and new wave scene. A mural commemorates the club, which closed in 2006, with changing portraits of musicians who got their break there.

In an industrial block in Nolita (North of Little Italy), a former garage houses a tacombi, a VW bus turned taco truck imported from Playa del Carmen, Mexico. Immigration from Mexico to NYC was not common before the 21st century, but it has boomed over the past two decades and boosted interest in authentic food.

Cyclists are more confident taking to the mean streets of New York City thanks to more bike lanes and safety in greater numbers: the Citi Bike share scheme has enabled 50 million rides between its launch in 2013 and late 2017. There are now more than 700 stations around the city for visitors and locals.

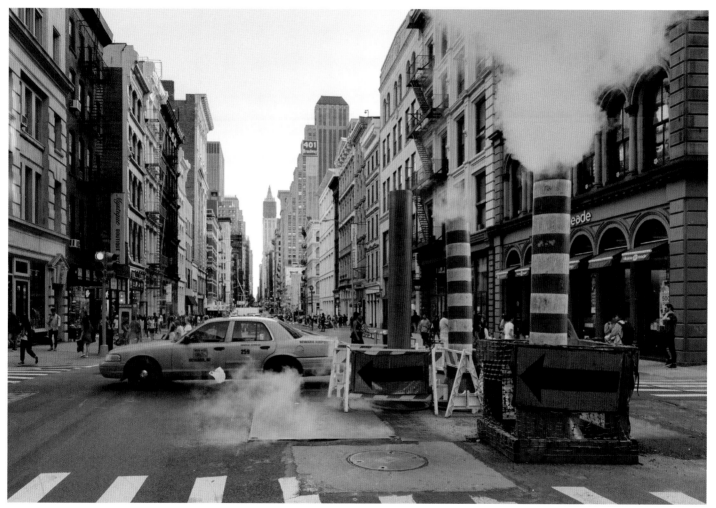

NYC's underground steam system often escapes above ground, as seen here on Broadway in Soho. The steam network provides services to many buildings – including the Metropolitan Museum of Art, Empire State Building and United Nations HQ – and even powers a rubbish-compacting system on Roosevelt Island.

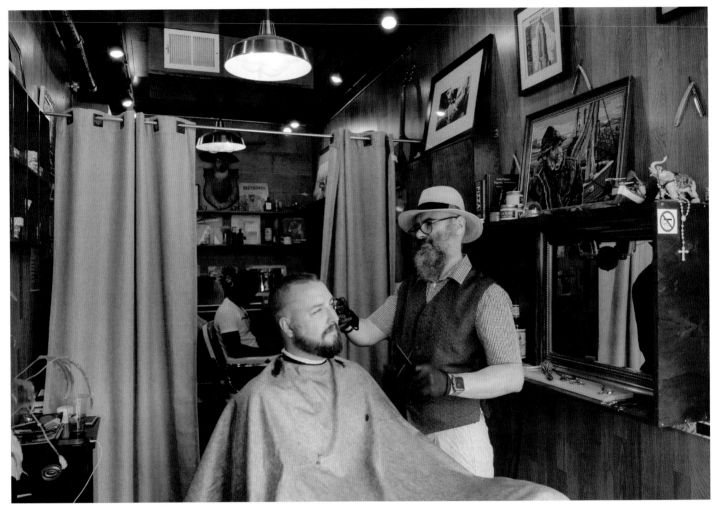

Beauty salons catering for women are already a huge business – New York City has more than 2000 nail salons, for instance, by far the most per capita in the country. It only follows, then, that NYC men would want their own space for a bit of 'man-pering'.

The West Village Tonsorial barbershop exudes a vintage feel from floor to ceiling, not least in the antique barber chairs, which are polished to a high shine and thus set the tone for the impeccable grooming on offer.

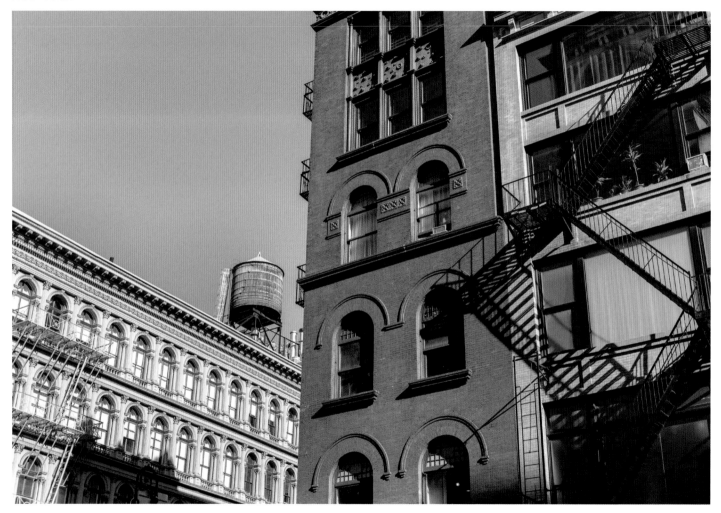

SoHo's sturdy cast-iron facades support another icon of the NYC skyline, wooden water towers. Although they look antique, the tanks are used every day to deliver water under pressure to large buildings. A typical tank holds about 10,000 gallons and many are built by a fourth-generation family company.

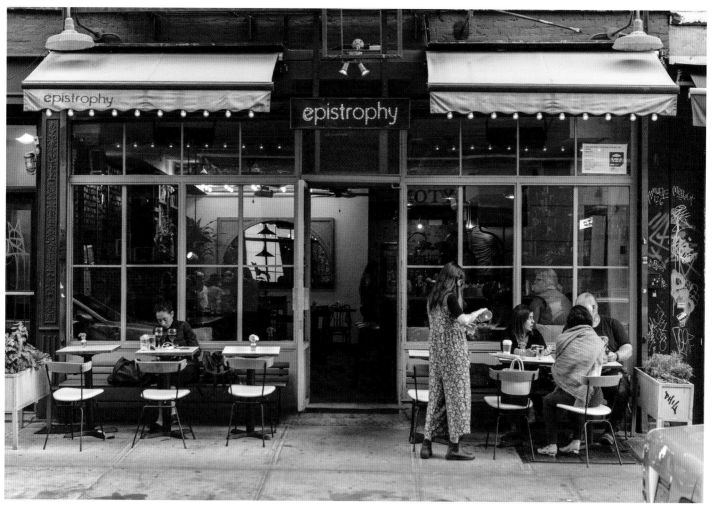

1300: Sidewalk cafes are ubiquitous now, but for a long time their expansion was not common, or even welcome, in the city. They were banned in 1933, and only returned in the early 1960s, when there were about 30, mostly in the West Village. Now the city issues more than 1,500 sidewalk-seating permits each year.

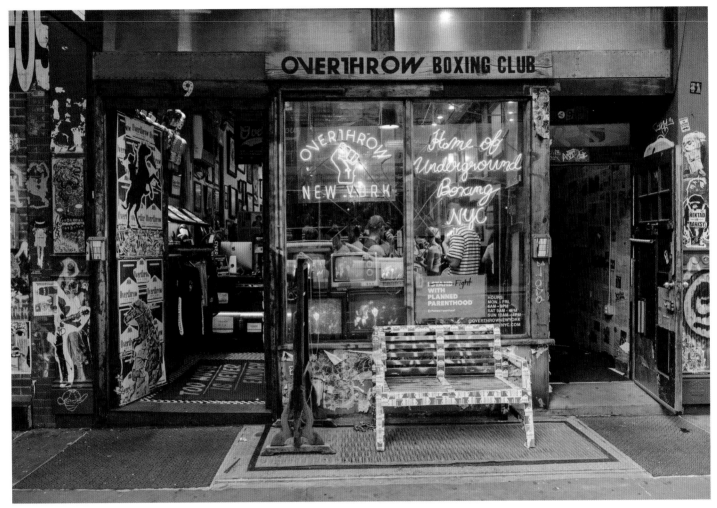

Overthrow Boxing Club, on Bleeker St in the East Village, occupies a townhouse where playful 1960s activist Abbie Hoffman set up headquarters for his Youth International Party, also known as 'Yippies' and 'Groucho Marxists' for their street-theatre pranks. The club is named after the group's newspaper, *Overthrow*.

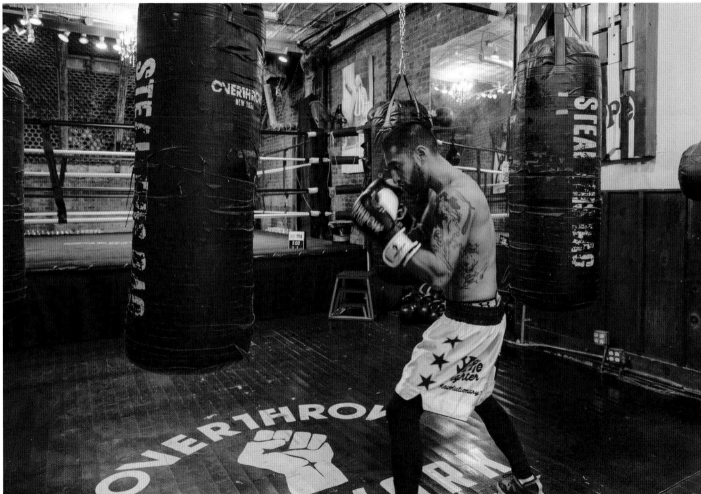

Boxing fits neatly with the adrenaline, aggression and energy of New York City. Training gyms had previously dwindled to only a handful in the outer boroughs, but newcomers such as Overthrow, opened in 2015, have attracted new people to the sport.

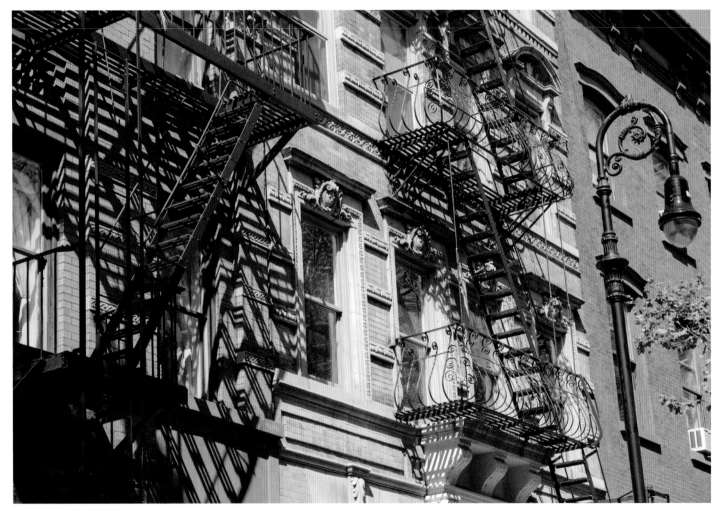

Zigzagging down building fronts, the external and often elaborately wrought metal fire escapes – here in the West Village – are a signature style across the city, having been introduced following the 1867 Tenement House Act, which first required New Yorkers to add them to their buildings.

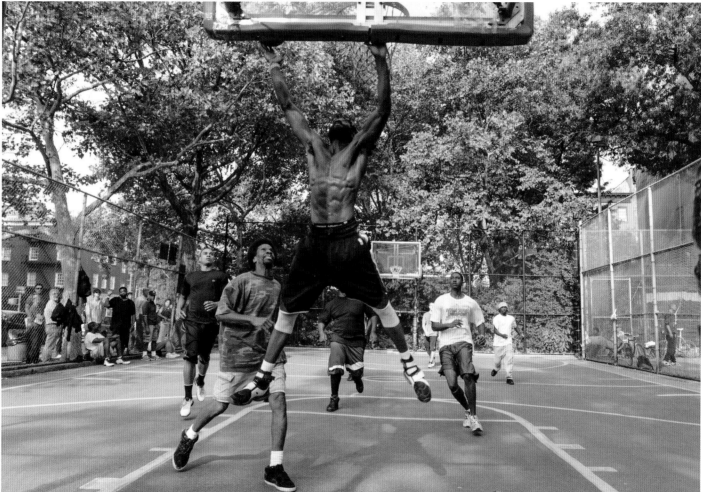

The basketball courts at West 4th St in the West Village, nicknamed 'the Cage' for their smaller-than-regulation size and chain-link fencing, are a hot spot for pickup basketball games between neighbourhood regulars and future NBA players. Aggressive, lively action often draws a crush of spectators to the fencing.

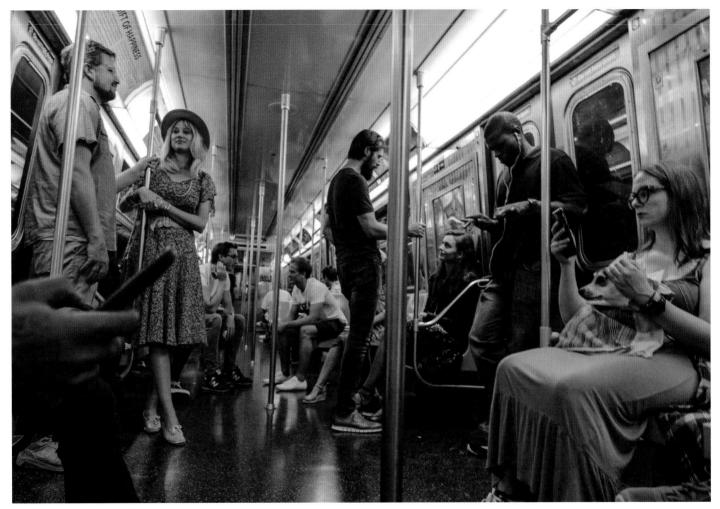

The G train, connecting Queens and Brooklyn, is the underdog of New York's subway system – and the only line that does not pass through Manhattan. But after a guest spot in *Girls*, and now filled with hipsters headed to Williamsburg and Greenpoint, it's finding a new lease of life, and its own fans.

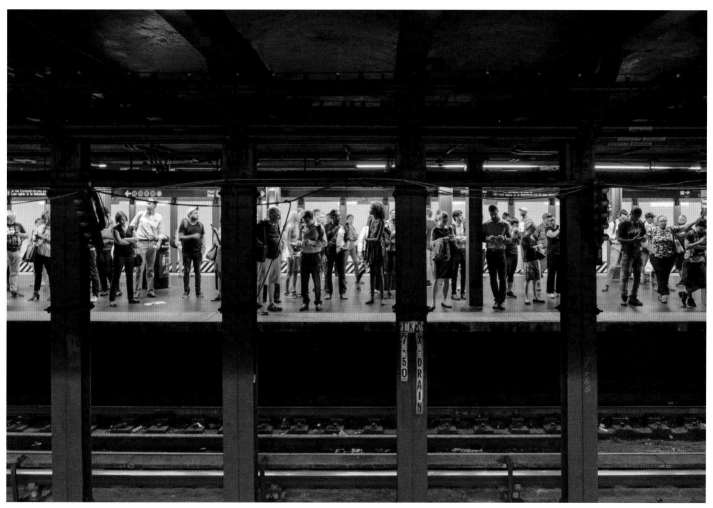

Spreading out from hubs such as Times Square, NYC's subway has 25 lines on 850 miles (1370km) of track. Passengers can ride from the Bronx to the beaches of Far Rockaway for a flat fare, and trains run 24 hours every day, making it one of only three such systems (along with Copenhagen and Chicago) in the world.

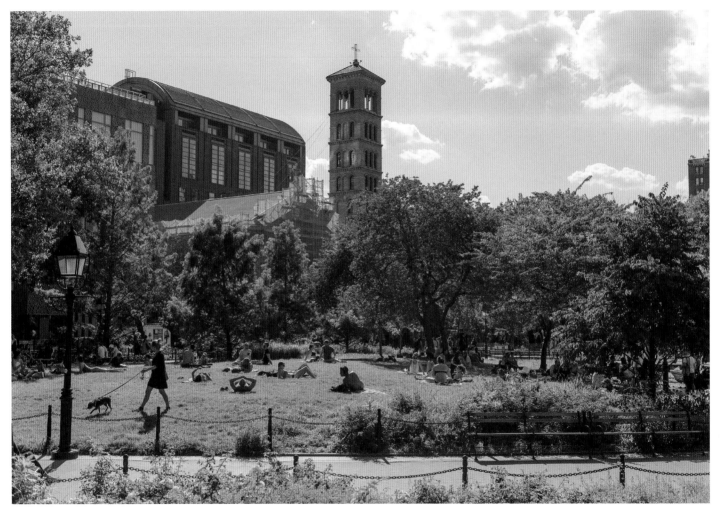

Washington Square Park, in the West Village, has lived many lives, from a marsh and public execution site to a burial ground for yellow fever victims and a military parade ground. Its current and much happier role is as the unofficial campus quad for NYU, which occupies many of the surrounding buildings.

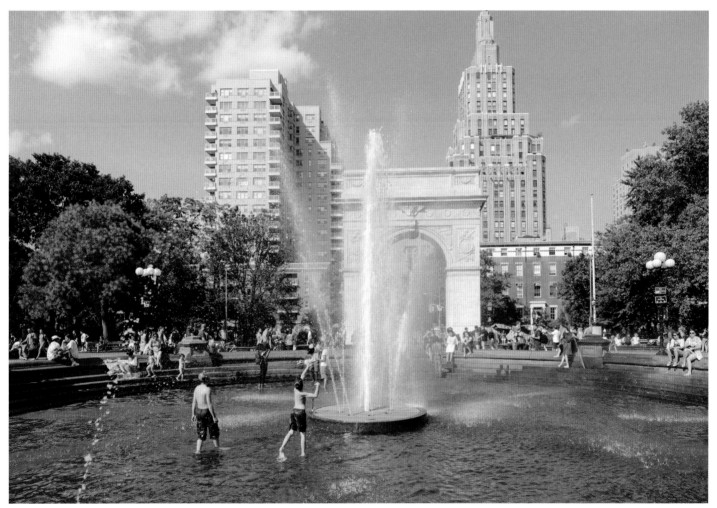

In the past decade, a three-phase park renovation programme devised by landscape architect George Vellonakis has included the renovation of the fountain and plaza through better accessibility, more seating, expanded lawns and a new mounded play area set in a meadow.

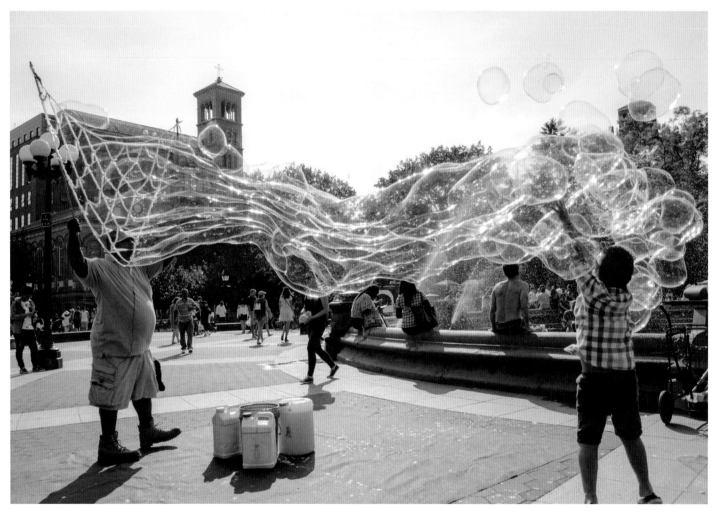

Activities and performers come and go, enlivening Washington Square's park life. More permanent fixtures include the chess tables on the west side, petanque courts and two dog-runs, ensuring that there's never any shortage of action here.

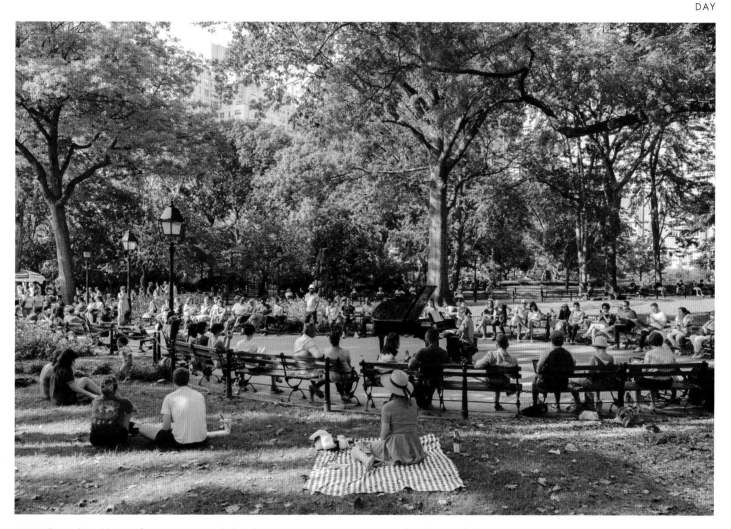

1400: The park's ad hoc performance space still plays host to some unusual acts, among them the so-called 'crazy piano guy' Colin Huggins, who has been playing here a few days a week for more than a decade. He wheels his baby grand from a mini-storage unit nearby.

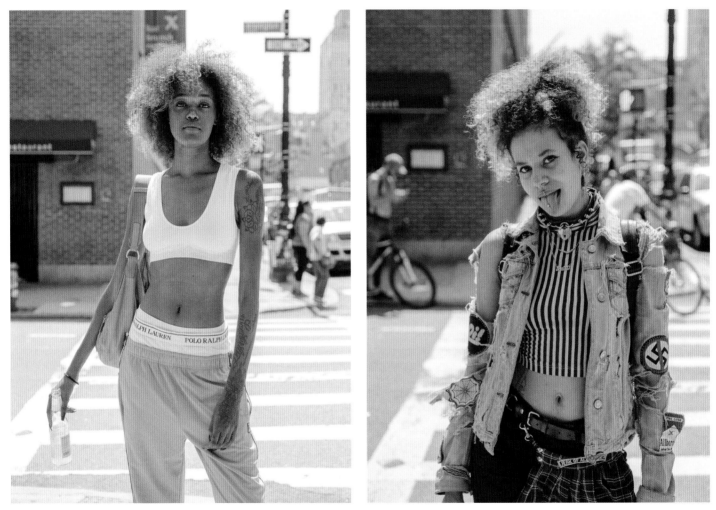

On the Lower East Side, down to the south-east of Washington Square Park, life – as well as street style – is a little more gritty. The street fashion of the Lower East Side takes its influences from 1970s punk style and contemporary antifa attitudes.

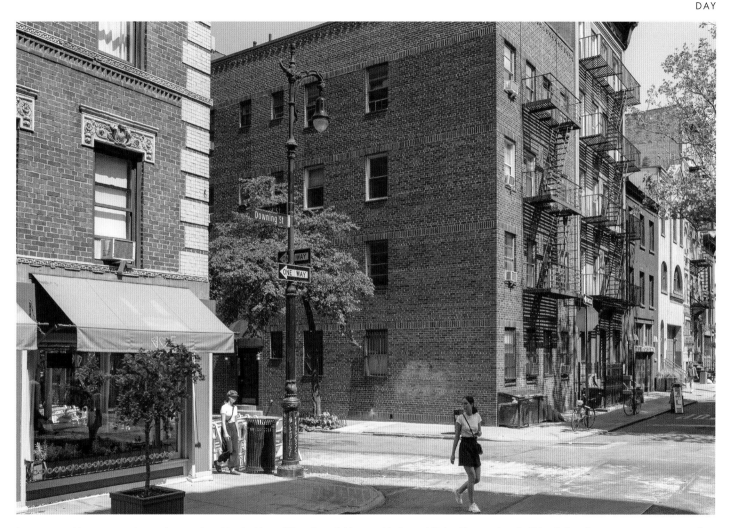

Its streets and bars may no longer be populated by the likes of Ezra Pound, Norman Mailer and Dylan Thomas, but the West Side still manages to retain a small-scale charm, thanks to its typical brick buildings and tree-shaded streets that often replace numbers and letters with names like Waverley, Christopher and Hudson.

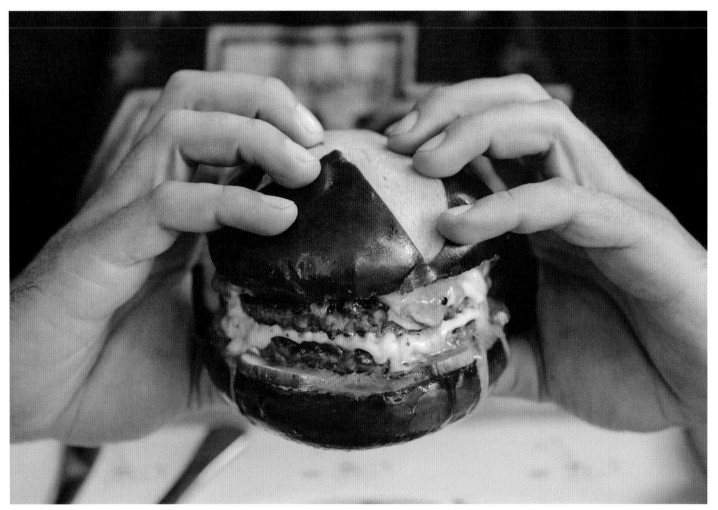

Premium burgers abound in NYC; they're an anchor even on some fine-dining menus. At the West Village restaurant Emily, which began as a Brooklyn pizza joint, pasture-raised, dry-aged beef is served with kimchi-spiked sauce and caramelised onion on a pretzel bun.

'Emily, which has two locations in Brooklyn and the West Village, is pretty unique for having not only one of the best pizzas in New York but also one of the best burgers, The Emmy Burger, as seen in the juicy photo. Some people recommend ordering a pizza as a side to the burger.'

- Guillaume Gaudet

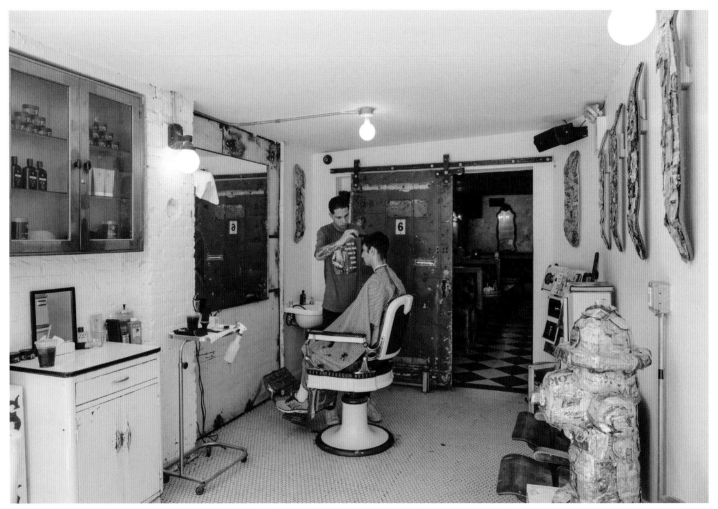

New York's small spaces, both commercial and residential, require creative solutions and multiple uses. The East Village's Blind Barber maximises its square footage by maintaining a bar and casual bistro in the back, speakeasy-style. Every customer who comes in for a haircut gets a free drink.

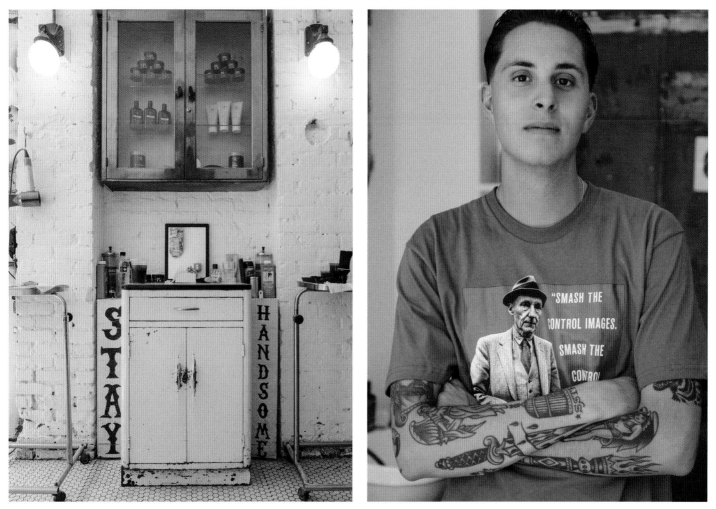

When it first opened in 2010, the Blind Barber billed itself as a bar that happened to have a barbershop out front. Its hair services and products have proven as popular as the drinks, however, and the brand has now expanded to Los Angeles and Chicago.

St Mark's Place (8th St) was the original cultural thoroughfare of the East Village, being dotted with theatres. The street has been home to Leon Trotsky, WH Auden, Abbie Hoffman, Lenny Bruce and Shulamith Firestone, among many other famous names.

Like most of Manhattan, the East Village has seen significant gentrification in recent decades. Changes began in 1988, when police forcibly cleared homeless people from Tompkins Square Park. A politically active squat scene has pushed back against development, and the neighbourhood has a striking mix of incomes.

New York doesn't have a lot of room for skateparks. Coleman Playground, between Chinatown and the Lower East Side, is one of the bigger sites.

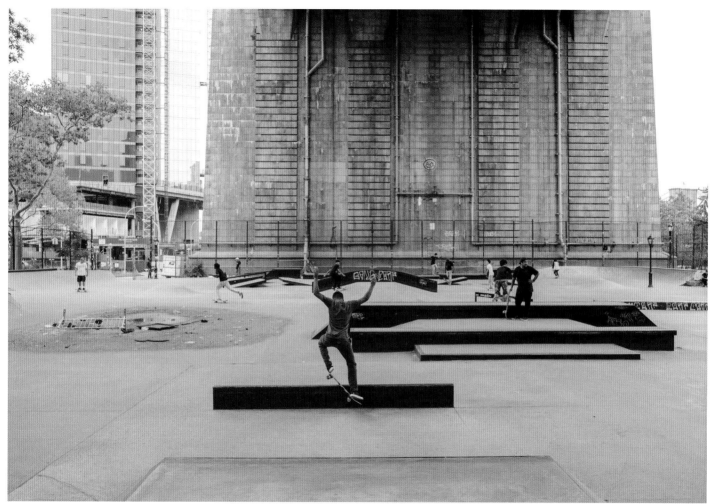

The skatepark's location beneath the Manhattan Bridge means that it stays in the shade for most of the day. Amid all the other ramps and obstacles dotted around, the park designers planted a shiny red apple – a *big* apple, naturally. There's also a key skatepark feature: ledges on which to sit while watching your friends' wipe-outs.

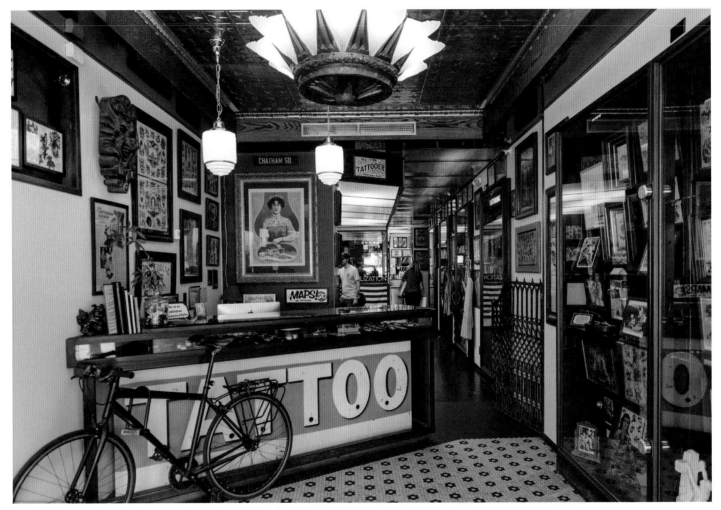

As Chinatown's Daredevil Tattoo reveals in its in-house museum, tattoo parlours were banned in New York City in 1961 in response to a hepatitis B outbreak. Only a few underground studios remained operational in Coney Island and the Lower East Side.

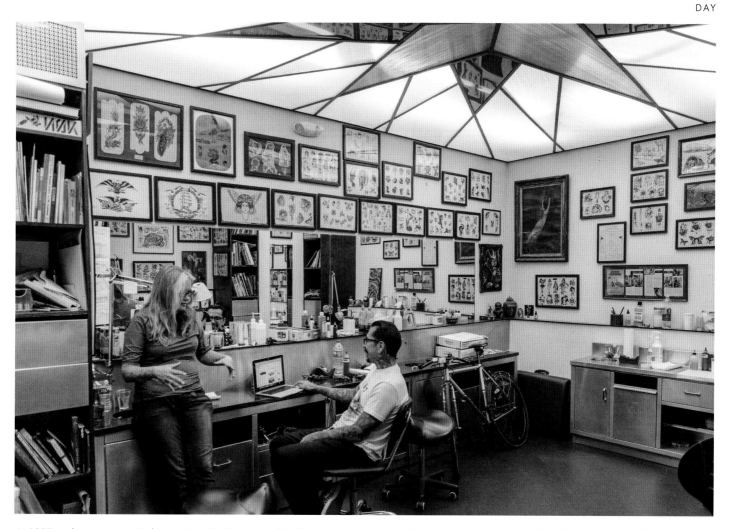

In 1997, studios were permitted again; Daredevil was one of the first to open at that time. The museum exhibits co-owner Brad Fink's extensive collection of tattoo memorabilia, amassed over the past three decades and including such curiosities as Thomas Edison's electric pen and early 20th-century tattoo machinery.

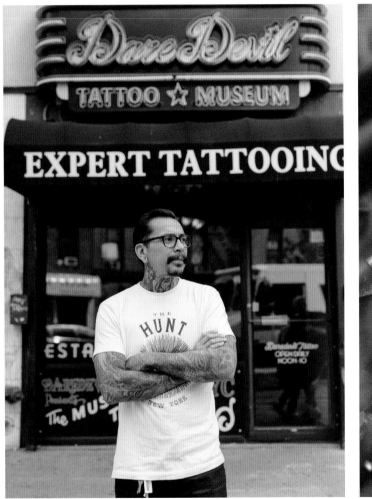

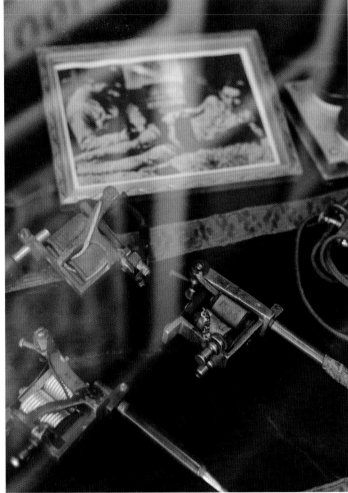

Aside from the 36-year break, tattooing has enjoyed a rich history in New York City. It all began with Native Americans and evolved in both style and design as it took in influences from the sailors of all nationalities who passed through the city.

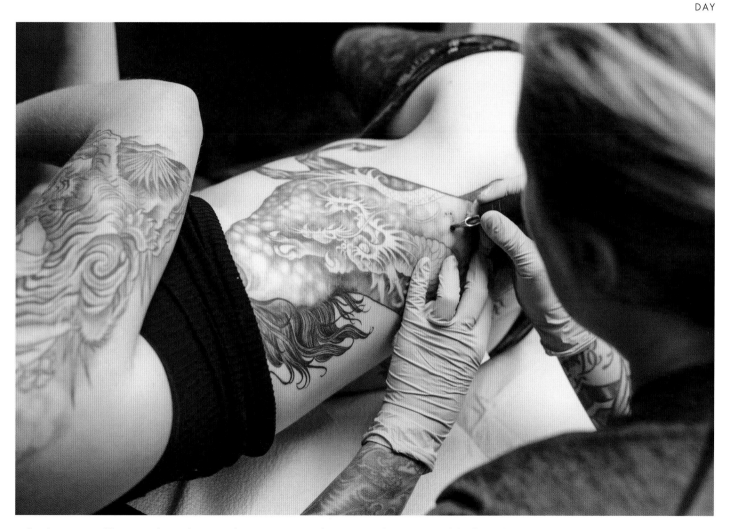

Today there are roughly 300 studios in the city and getting a tattoo is, for many, not the stereotypical drunken lark but an investment in a piece of individually commissioned art. In summer, some neighbourhoods can feel like walking galleries.

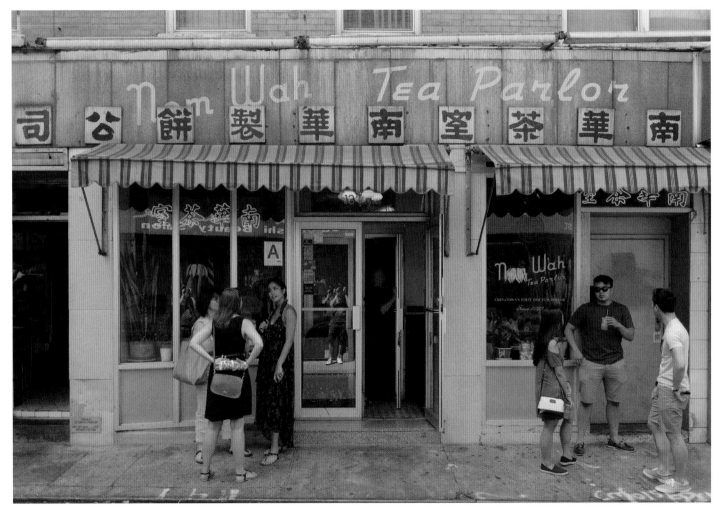

On crooked Doyers St in Chinatown, Nom Wah is a classic tea house, opened at number 15 in 1920 to serve Chinese pastries, steamed buns, dim sum and tea. It was later transformed into a dim sum restaurant next door to the original by the young nephew of the longtime owner.

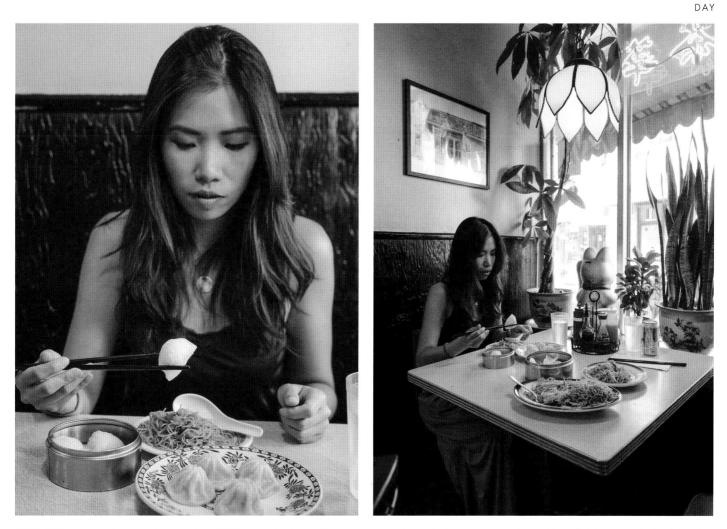

NYC's Chinatown has been in existence since 1880, and its businesses have grown and changed with every generation. At Nom Wah, however, the food, like the decor, remains true to its old-school traditions.

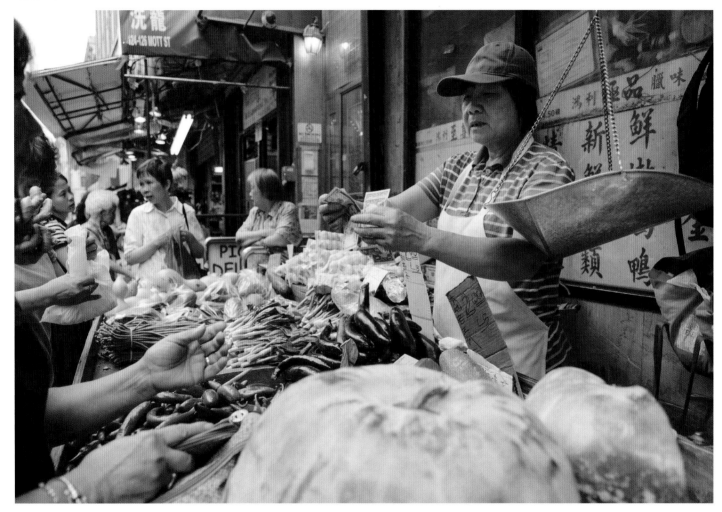

Street vendors in Chinatown spill out from established businesses or set up shop on corners for a week or two only, when a certain crop – fresh peanuts, for example – is in season and provides a cheap and plentiful supply.

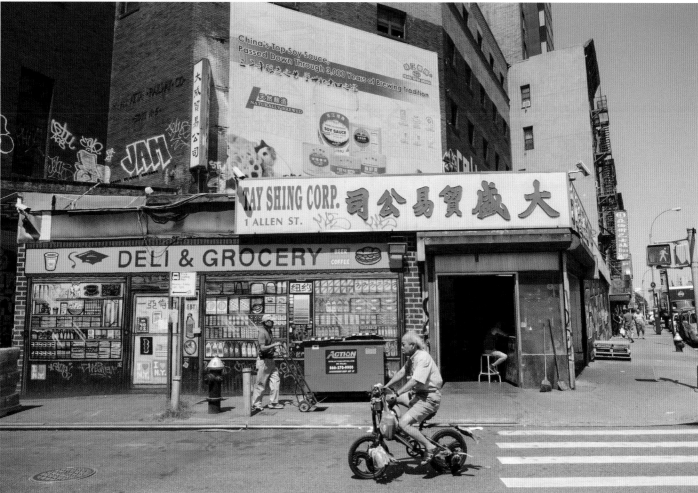

The eastern edge of Chinatown is primarily home to newer immigrants, from Fujian province. They're probably best known to other New Yorkers for introducing the ultra-cheap 'Chinatown bus' services, designed to transport restaurant employees to connecting cities all over the East Coast.

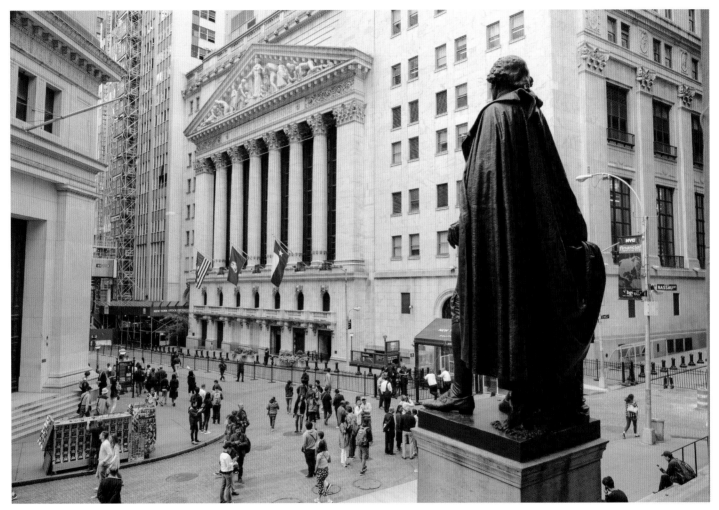

Wall Street is synonymous with finance, but it's also a key spot for government. George Washington was sworn in as president at the corner of Wall and Broad (now Federal Hall), and Congress first convened here. Washington still presides, his statue looking south to the colonnaded New York Stock Exchange.

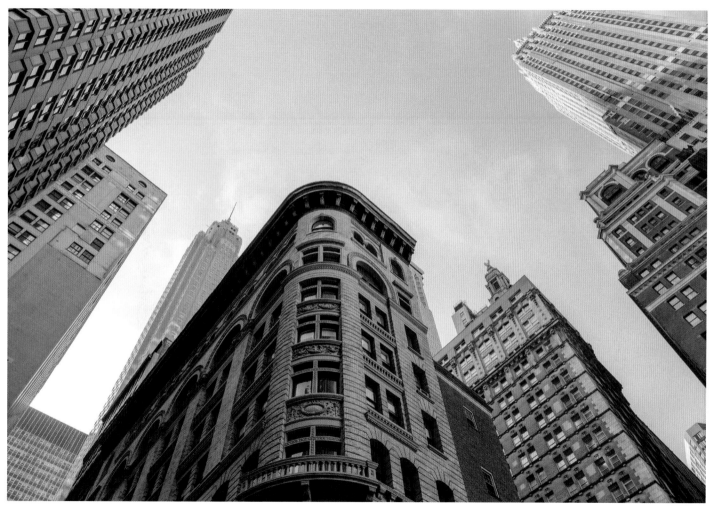

Amid the early 20th-century towers of the Financial District and the 21st-century behemoths that dwarf those first skyscrapers, relatively small buildings survive, their 19th-century neo-Renaissance styling prized as early examples of the city's architectural majesty.

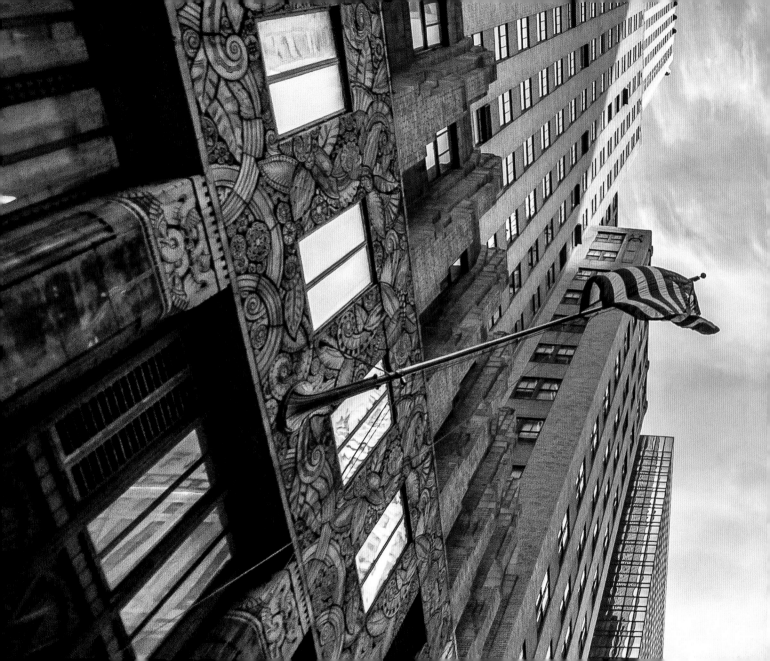

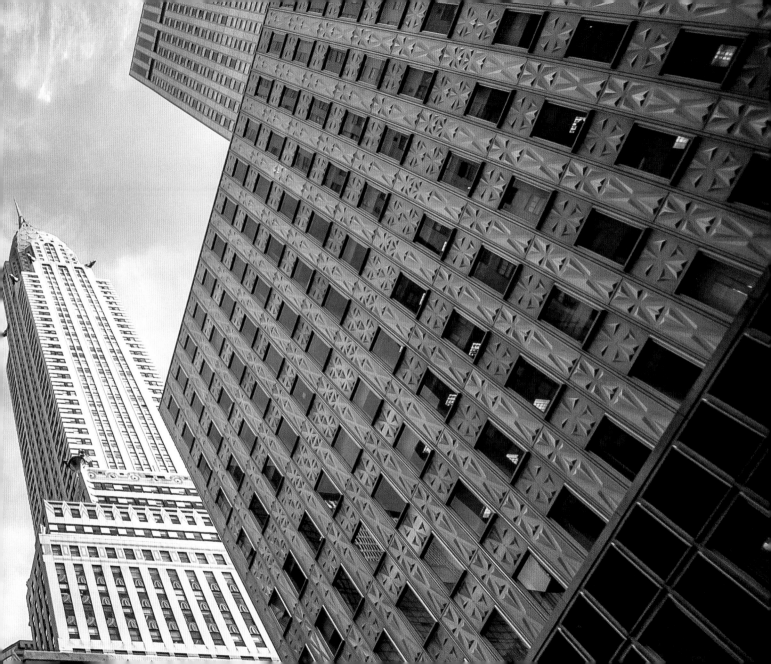

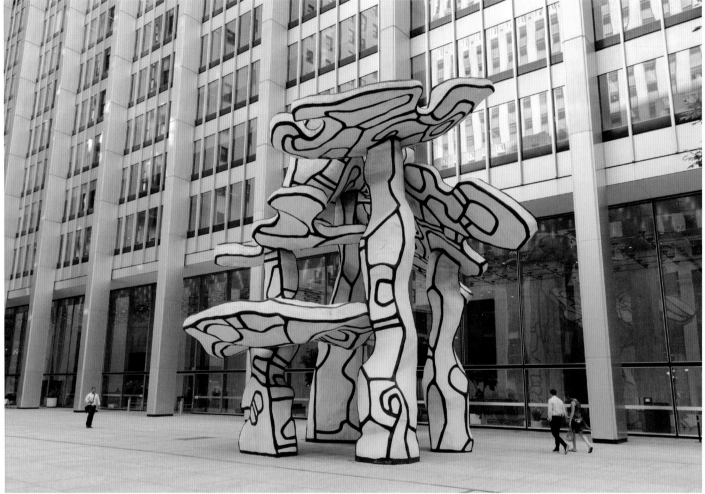

Public artworks dotted around the Financial District's plazas contrast strikingly with its skyscrapers – as above where Jean Dubuffet's *Group of Four Trees* towers over pedestrians but is a minnow compared with the Chase Manhattan Bank building behind it.

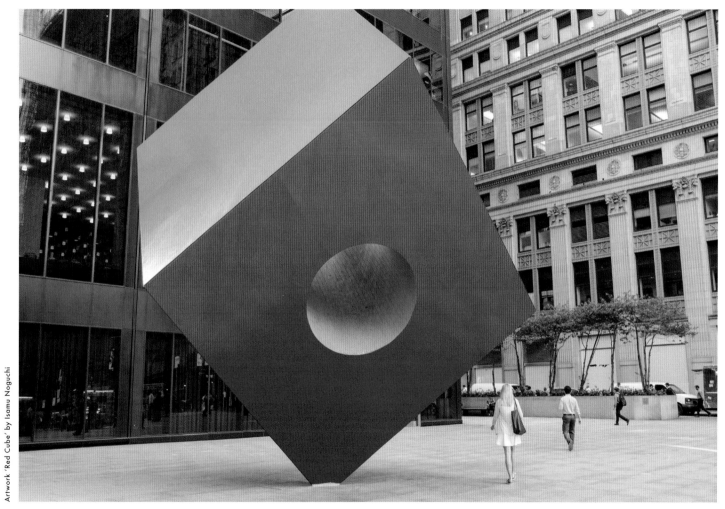

Artwork 'Red Cube' by Isamu Noguchi

Japanese-American sculptor Isamu Noguchi's *Red Cube* lends colour to a Financial District plaza in front of the HSBC (previously the Marine Midland Bank) building on Broadway. Despite its title, the sculpture is not actually a cube.

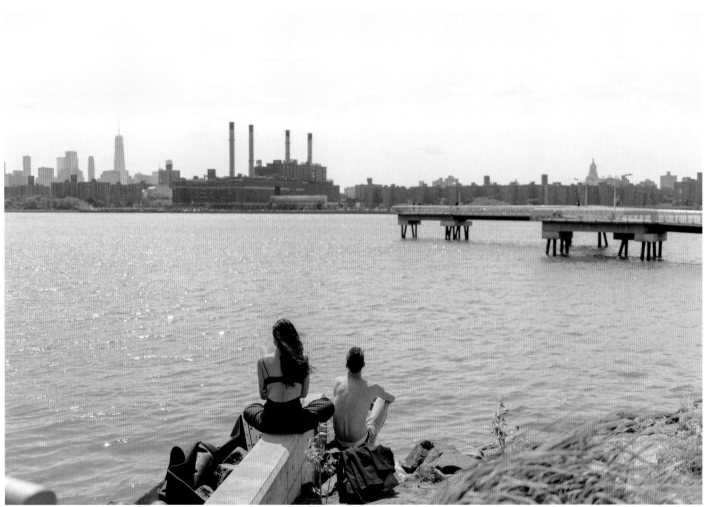

1500: Over 15 years, Brooklyn's waterfront has been developed into a series of parks. WNYC Transmitter Park, in Greenpoint, filled in the industrial zone where the city's public radio station antennas used to be.

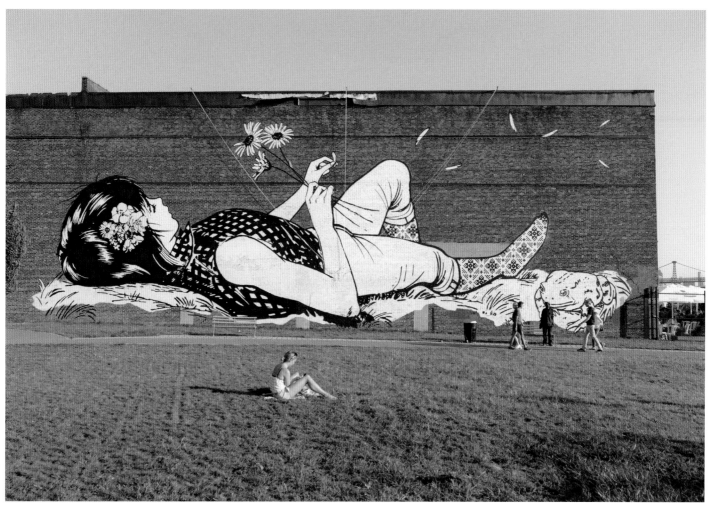

Artwork by Faile

The large-scale artwork in WNYC Transmitter Park was created by Faile art studio, a Brooklyn-based artistic collaboration between Patrick McNeil and Patrick Miller. Entitled *Love Me, Love Me Not*, it questions our relationship with nature, and uses a traditional Polish pattern on the socks as a nod to Greenpoint's Polish community.

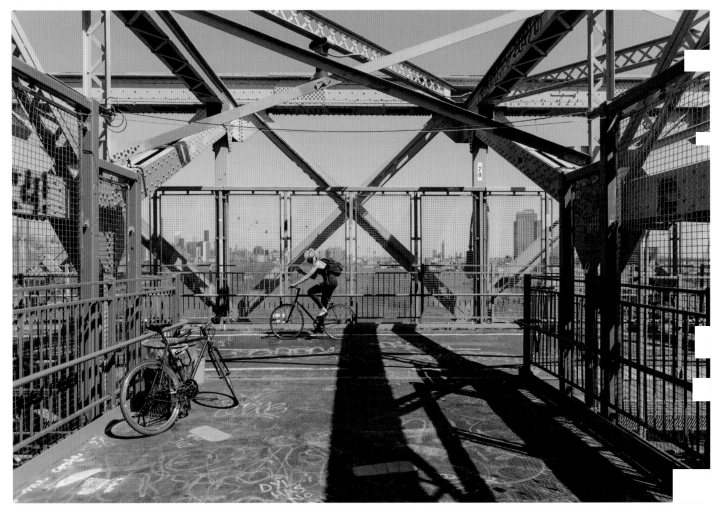

Williamsburg Bridge, connecting Brooklyn and Manhattan, opened in 1903 but was poorly maintained. In 1988, it was closed to traffic when massive rusted holes in the girders and more than 200 snapped cables in the suspension were discovered. It was significantly rebuilt over the next decade.

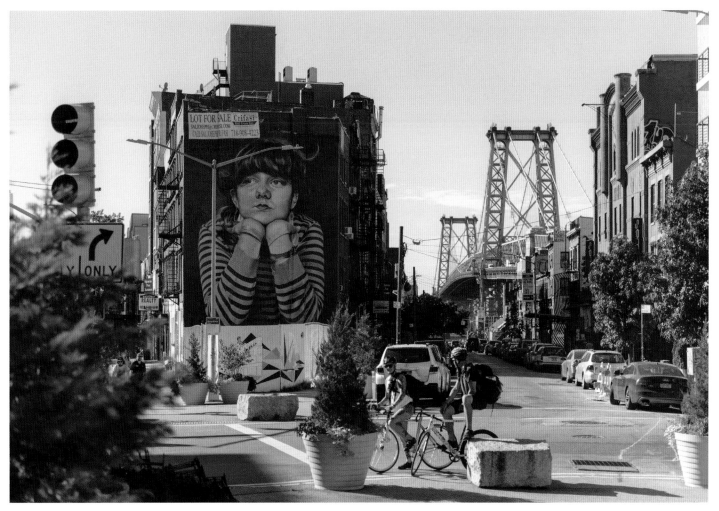

The *Mona Lisa of Williamsburg*, a 2014 mural rendition of a photo by then 17-year-old high-school student Steven Paul, graces a building near the foot of the Williamsburg Bridge, overlooking Broadway Ave at the corner of Bedford Ave.

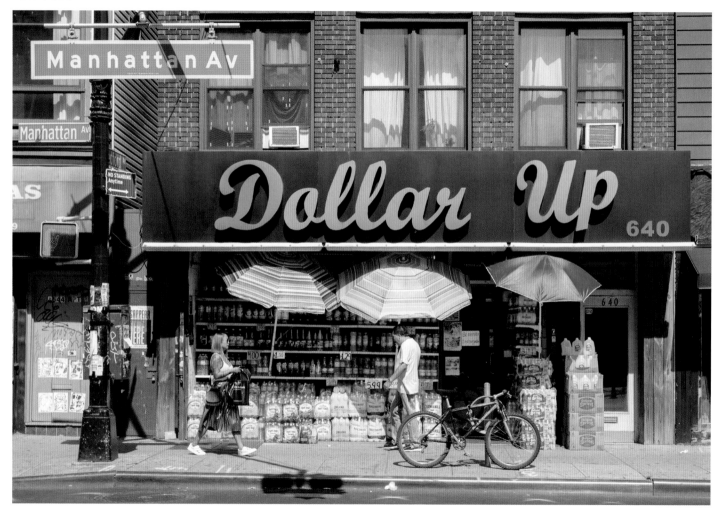

Greenpoint's Dollar Up, and dollar stores like it all over the city, are essential to budget apartment life, stocking everything from cheap toilet paper to extra plates and glasses. Bonus: the stores are open very late, for those homemaking emergencies.

To wait or not to wait? This is the brunch question every New Yorker faces. Cool Brooklyn, including Greenpoint, excels in spots that make the wait worthwhile, with queues that are a kind of social scene, and innovative plays on sweet and savoury once you sit down.

Since Smorgasburg food market began in 2011, it has spun off to locations well beyond its original Williamsburg base, spreading as far upstate as to Kingston, NY, and even to LA, where a weekly Smorgasburg market has been taking place Downtown since 2016.

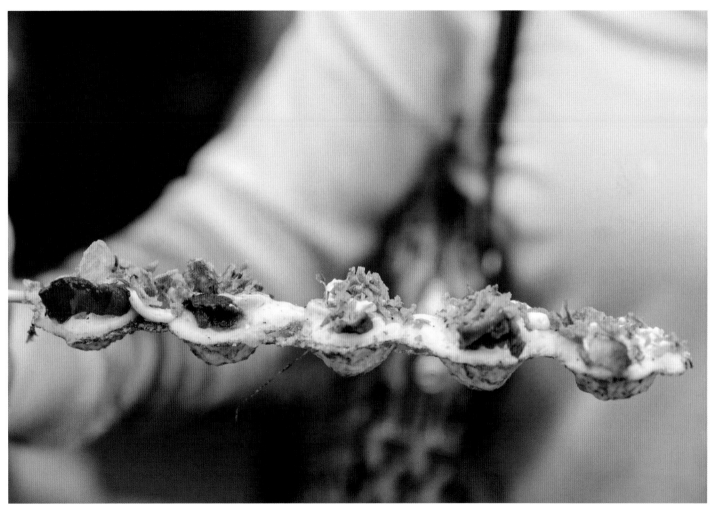

Getting a booth from which to sell goods such as these Thai *poffertjes* is competitive. Vendors are vetted in several tastings and in-person interviews, and the curators select for flavour as well as international variety.

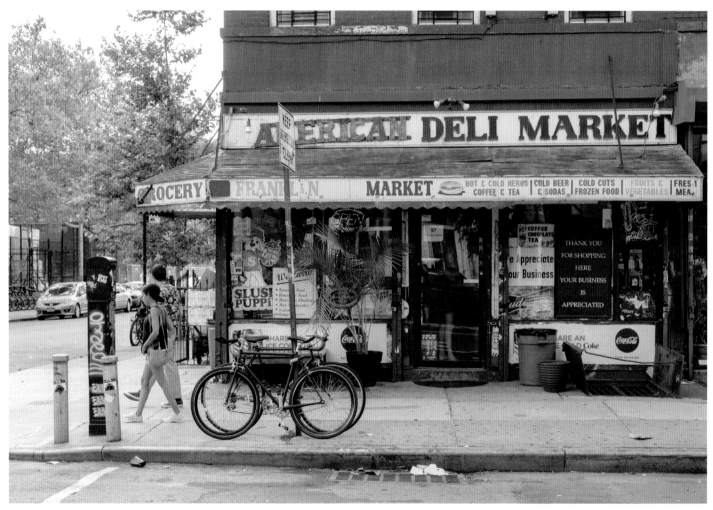

New Yorkers adore their bodegas, or corner stores. The versatile shops are reliable for fast coffee, egg-and-cheese on a roll and other morning staples, as well as basic groceries, cleaning supplies and an ATM. The best bodegas have a good beer selection and a friendly resident cat.

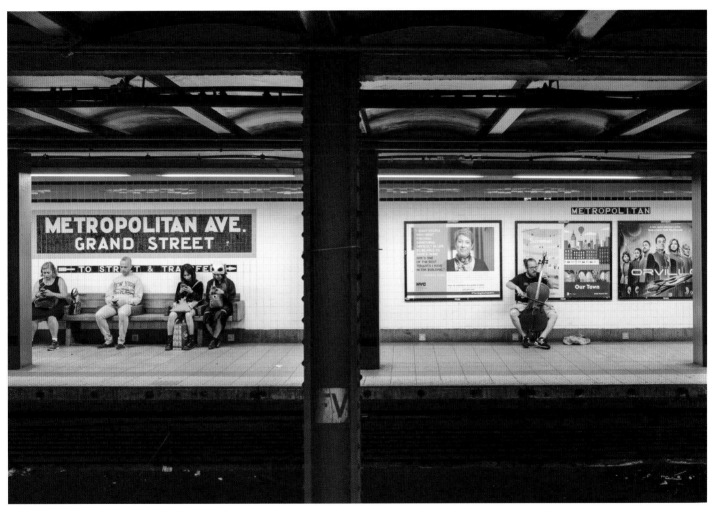

Subway station acoustics are kind to platform musicians. An official city programme, Music Under New York, selects some 350 performers via auditions and assigns them large spaces. But at less-trafficked stations, rogue soloists can also perform.

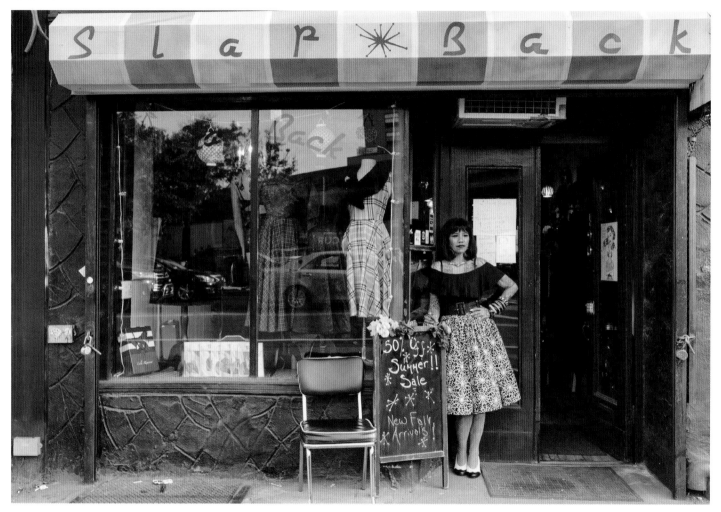

Vintage style thrives in Williamsburg, where quirky small businesses are still the norm. The neighbourhood developed its current style in the 1990s, when it was considered the 'East East Village' – the next logical step along the L train line for people priced out of Manhattan's most creative corner.

SlapBack, on Metropolitan Ave in Williamsburg, is a full-on time warp. The shop specialises in classic vinyl and rockabilly fashion – both vintage and newly designed – plus all the other trimmings necessary for a fabulous retro lifestyle.

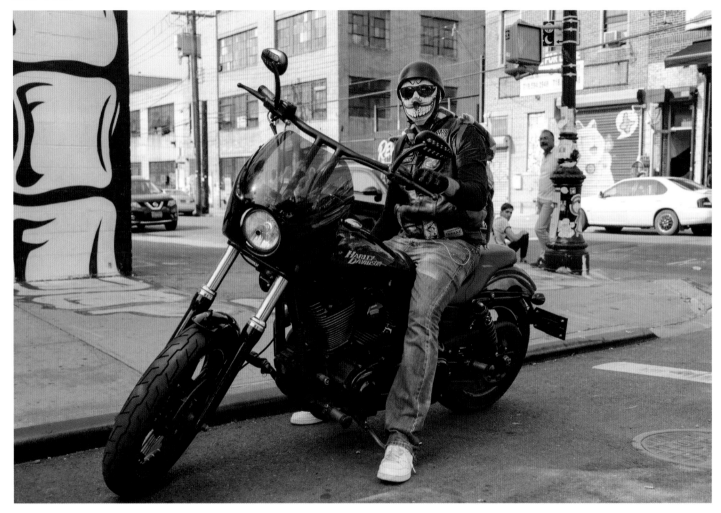

New York doesn't offer much open road, but that doesn't deter this biker in Bushwick, where the sheer amount of inventive art, particularly on Troutman St between Cypress Ave and Irving Ave, may have contributed to his own personal creativity.

Prospect Park is Brooklyn's equivalent of Central Park – though a bit smaller, at 526 acres (213 hectares). Frederick Law Olmsted co-designed both with Calvert Vaux, in a signature mix of wild and tame areas, furnishing Prospect Park with a zoo. It also has a 1912 merry-go-round that was originally at Coney Island.

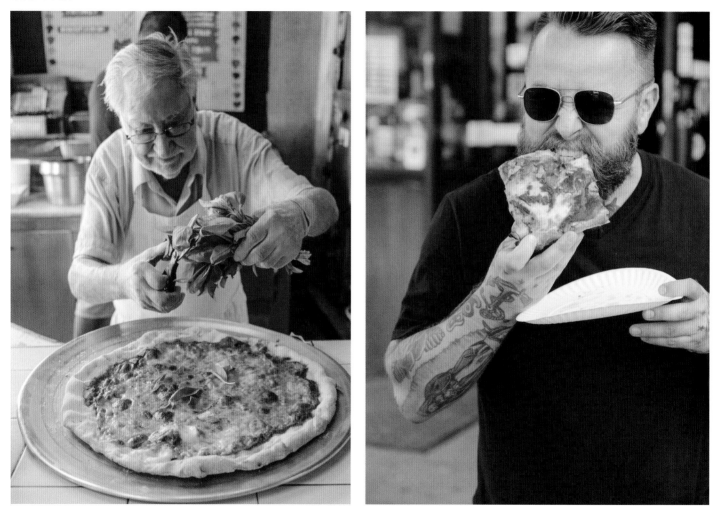

The location of Di Fara in Midwood, Brooklyn is a trek, and the prices are double the Manhattan average, but pizza connoisseurs from the city and around the world happily make the journey just to taste owner Domenico DeMarco's handiwork.

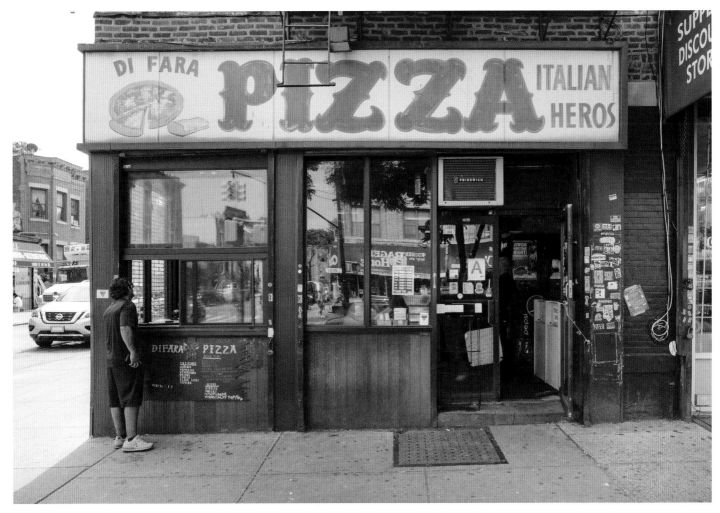

New York City runs on pizza. Di Fara, established in 1965, is considered one of the very best, but slices and pies are available across all five boroughs, from casual to formal and cheap to extravagantly priced.

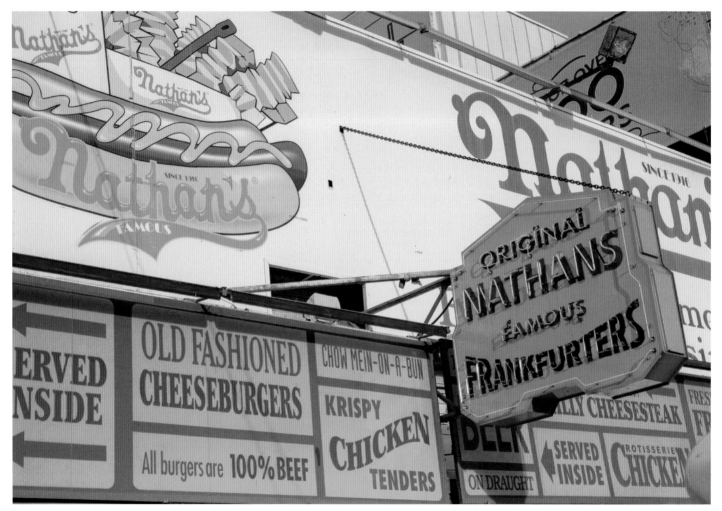

A landmark in Coney Island, Nathan's serves every fast food you can imagine, but it's most famous for its hot dogs. They're also served at shops and street carts around the city, but they taste best in the salty air by the ocean.

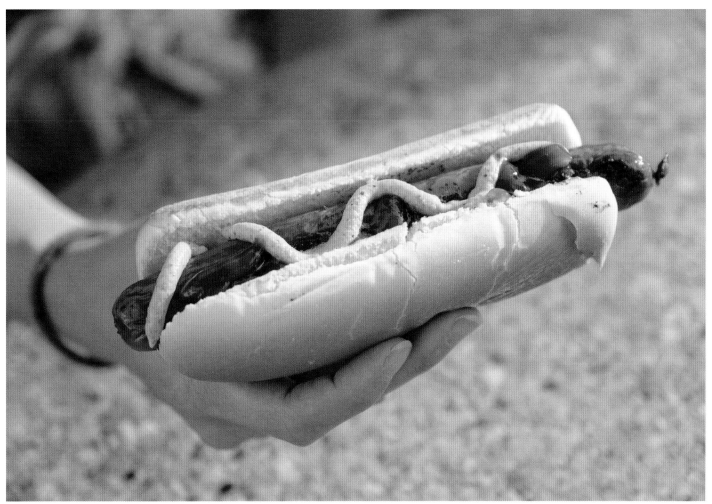

Nathan's hosts an annual hot-dog-eating contest on 4 July at its original Coney Island restaurant, on the corners of Surf and Stillwell. Joey 'Jaws' Chestnut holds the record as of 2017, having chomped his way through 72 frankfurters, buns included.

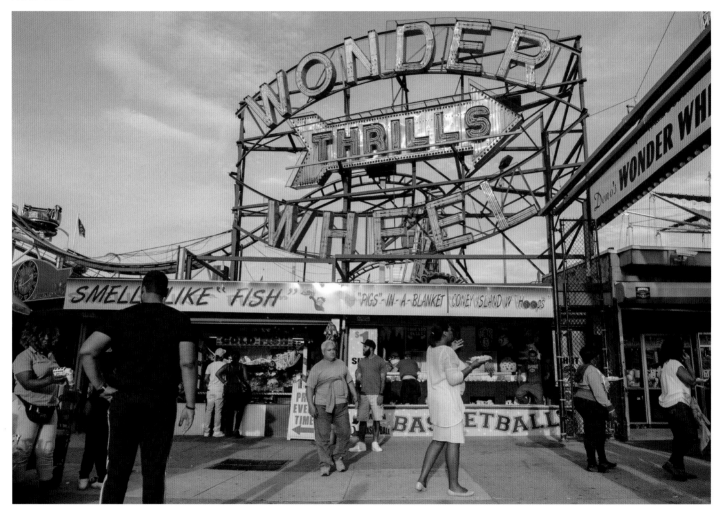

Coney Island is best-known for its strip of thrill rides and games along the boardwalk facing the beach. Although a new roller coaster was added in 2014, the place is known more for its older, vintage-style rides, such as the wooden Cyclone roller coaster and the Wonder Wheel.

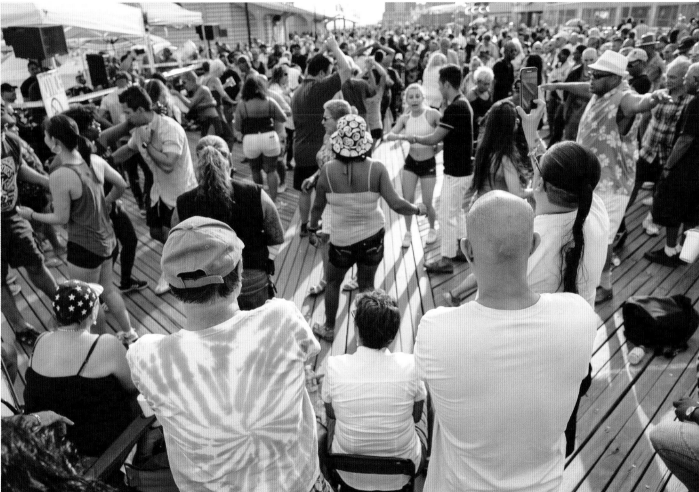

On summer weekends, the Coney Island boardwalk is one long social scene, with music and impromptu dance parties. The famed boardwalk runs 2.5 miles (4km) alongside the Atlantic Ocean, from West 37th St to Brighton 14th St at Brighton Beach.

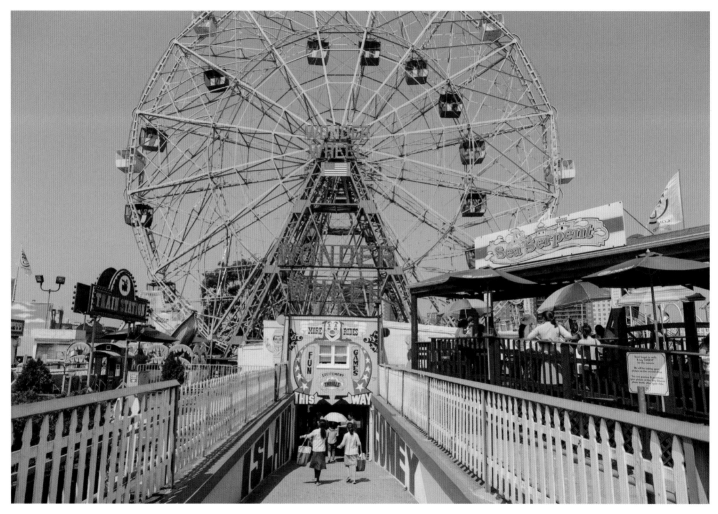

From the late 19th century through World War II, Coney Island drew vacationers from across the country to its multiple amusement parks, side by side along the boardwalk. Now it's more a local attraction, though the Wonder Wheel has been operating steadily since 1920.

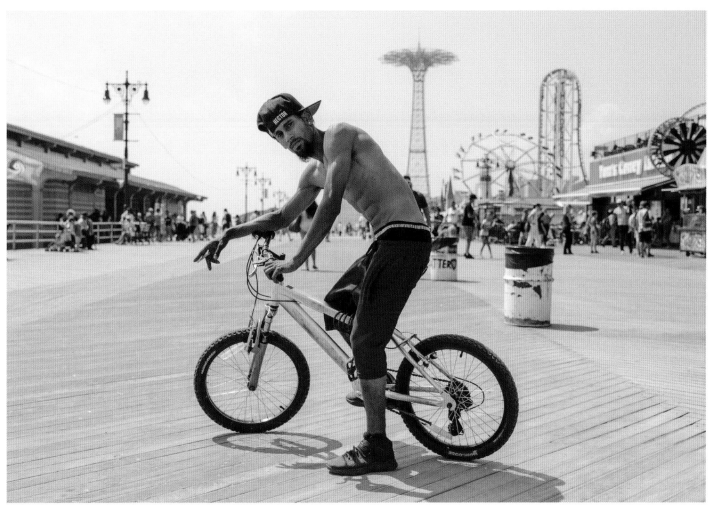

In 2012, flooding from Hurricane Sandy destroyed much of Coney Island's boardwalk and trapped residents in the apartment towers behind the beach. By the next summer, though, the beachfront was restored and better than ever.

'Coney Island Pier is a good example of the changes that New York has faced over the past decade. I shot a great street photograph here seven years ago: a kid jumping from a rusty pier over a 'No Swimming' sign. Now there are no more kids diving, the pier has been renovated and there are park guards at the entrance. The only action left to shoot is guys catching fish. I was lucky to capture one at the right moment.'

- *Guillaume Gaudet*

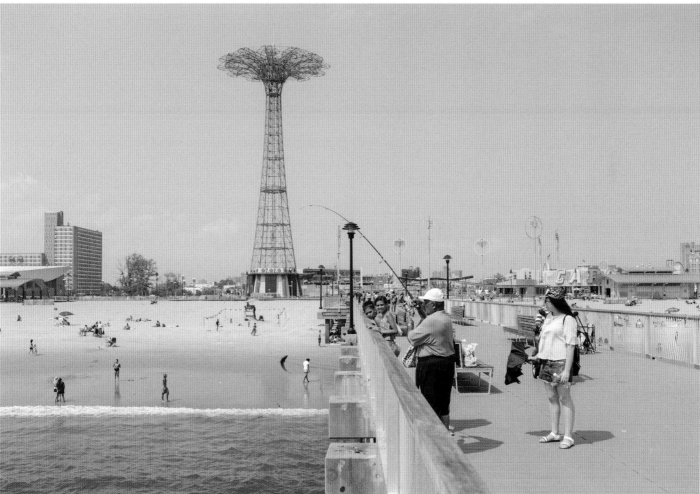

The red tower of the Parachute Jump, dubbed 'the Eiffel Tower of Brooklyn', is probably the best-known icon of Coney Island, even though the 250ft-tall (76m) ride ceased operation in 1964. Since 2013, it has been trimmed in LED lights that flash patterns up and down the tower at night.

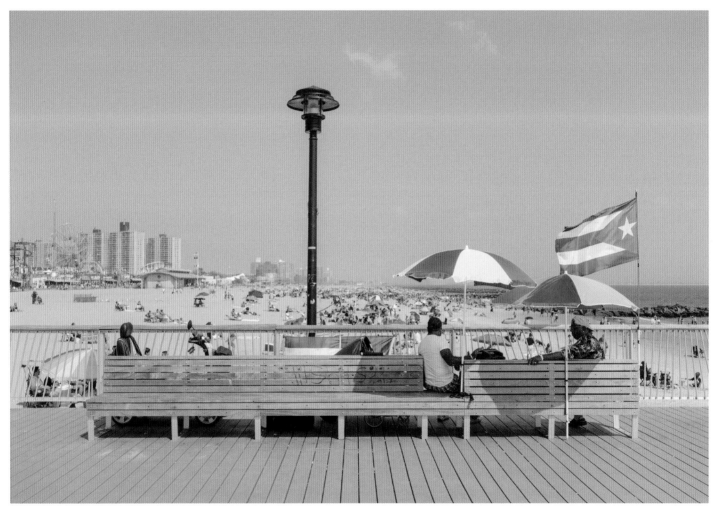

East of Coney Island's beach, past the New York Aquarium and its 332ft-long (101m) cast-concrete sculpture wall by artist Toshio Sasaki, is Brighton Beach, home to a large Russian immigrant community.

New York City is home to more than 700,000 Puerto Ricans, For June's Puerto Rican Day Parade, the beach is a popular afterparty destination.

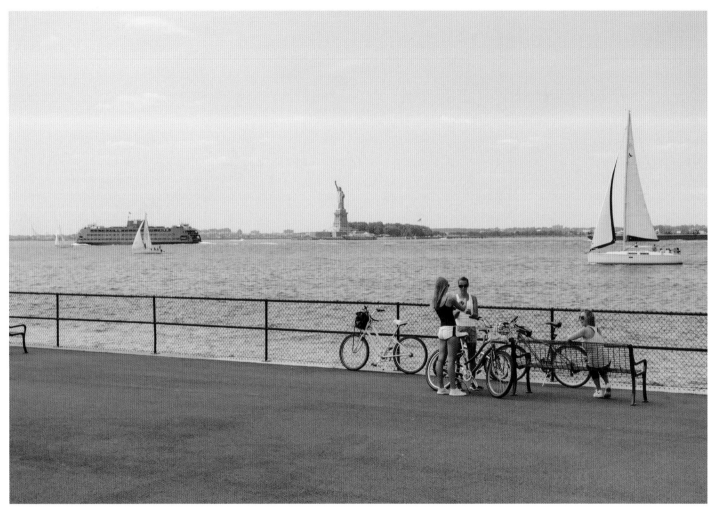

It's rare that a city gets a whole new piece of land, but that's what Governors Island is to most New Yorkers. Long a base for the army, then the coastguard, it was abandoned in the 1990s. The city bought part of it for US$1 and has developed it as a park.

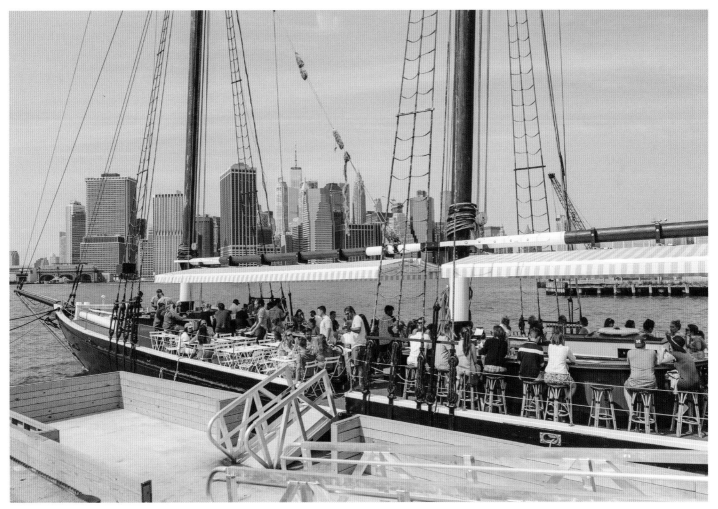

1700: A 1924 racing schooner off Brooklyn Bridge Park serves cocktails and fresh oysters. New Yorkers were historically voracious oyster-eaters, but overfishing and pollution almost made the shellfish extinct. Now local bivalves are growing again, but they're used for improving water quality, not as food (yet).

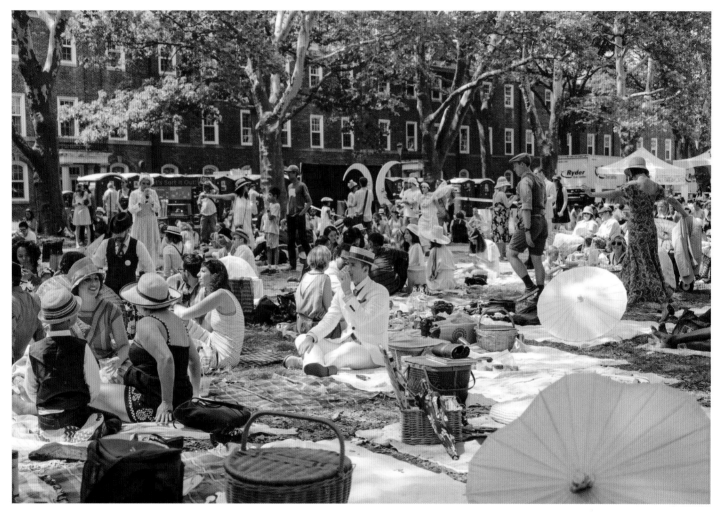

Every summer since 2005, Governors Island has hosted the Jazz Age Lawn Party, conceived by jazz age fan and musician Michael Arenella as a tribute to the Roaring '20s. The redbrick buildings that once made up the old army base are a tasteful backdrop to the hugely popular event.

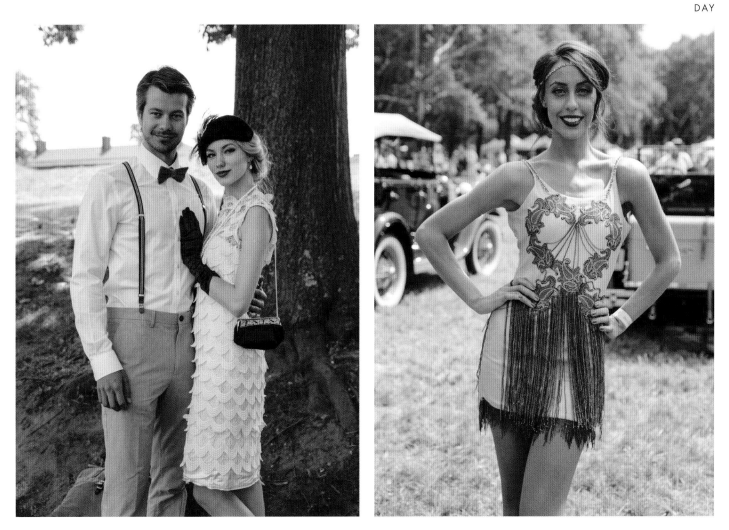

Jazz Age Lawn Party attendees celebrate the raunchy Prohibition era by sporting the fashions of the time. F Scott Fitzgerald wrote about the New York City elite, so affection for him and Gatsby-style glamour is still strong here.

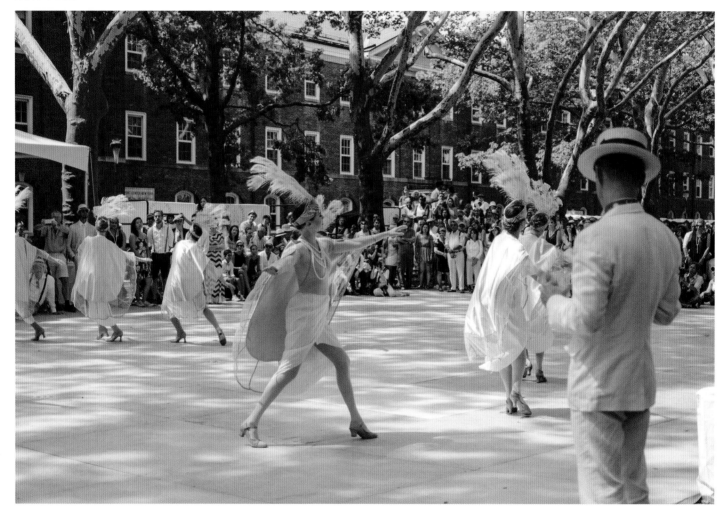

At the party, the Dreamland Follies perform to orchestral accompaniment. They take their inspiration from the Ziegfeld Follies, a series of Broadway shows with glamorous, feather-clad chorus lines (which also inspired the Rockettes, who still perform at Radio City Music Hall).

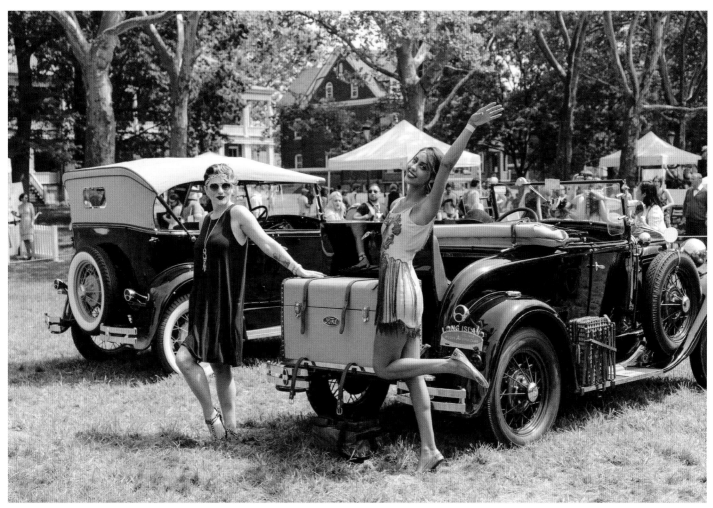

In addition to music and dancing, the Jazz Age Lawn Party includes such activities as a croquet tournament, a vintage bathing-costume promenade, an old-time car show and even a pie contest. In keeping with the Prohibition theme, bakers are encouraged to incorporate alcohol in creative ways.

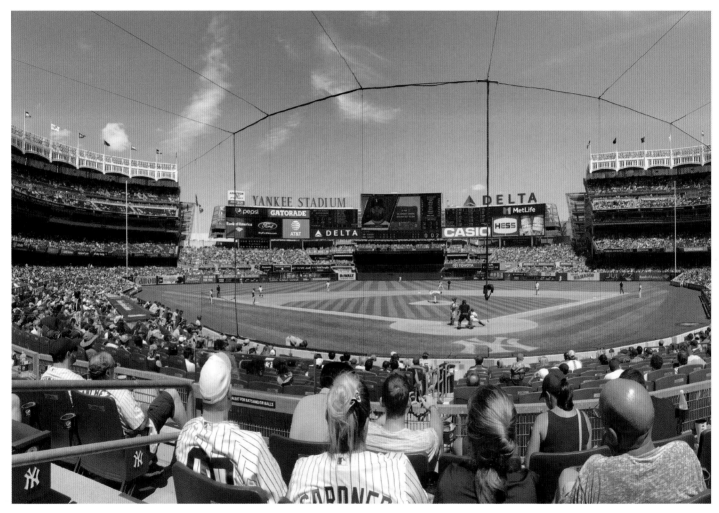

The newest stadium for baseball team the Yankees seats 47,422 fans (and a few dozen more in 68 luxury suites) but was beset with troubles during its construction; the finished arena's total price tag makes it the most expensive stadium ever built.

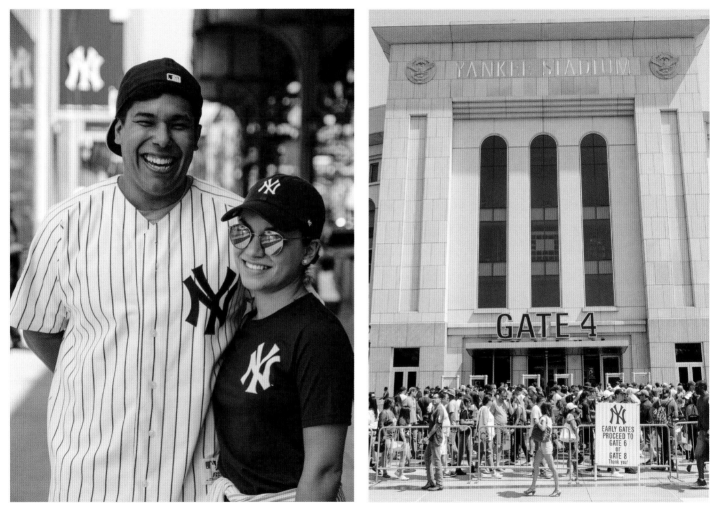

The Yankees' navy pinstripes are one of the most recognisable kits in baseball but it was the Chicago Cubs who started the pinstripe trend in the early 20th century.

The new stadium opened in the Bronx in 2009, adjacent to the previous one. It looks older: the limestone exterior mimics the team's first stadium, from 1923.

123

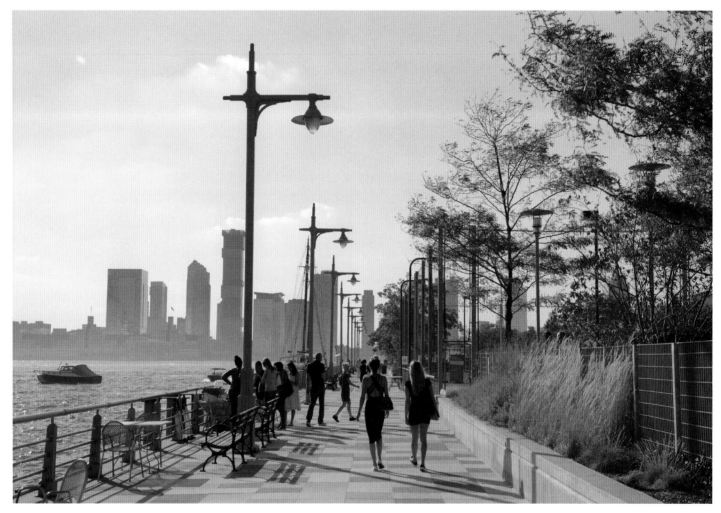

Along the Hudson River in Tribeca, the waterfront path is a series of converted piers forming part of the longer Hudson River Greenway (the longest greenway in Manhattan), which in turn is part of the much longer East Coast Greenway, a 3000-mile (4,800km) trail system linking Maine with Florida.

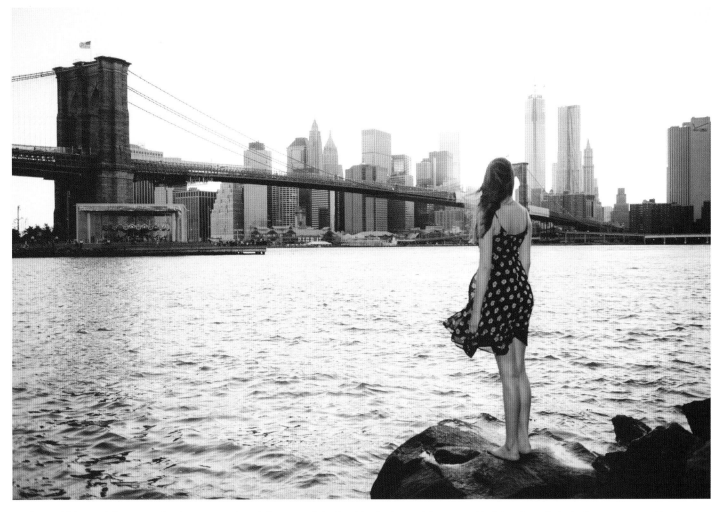

Dumbo's Pebble Beach faces west for the sunset and south for views of the Brooklyn Bridge and the carousel in Fulton Ferry Park. As the sun sets over Manhattan, the city's energy dips just slightly – the commute home is quieter than the ride in.

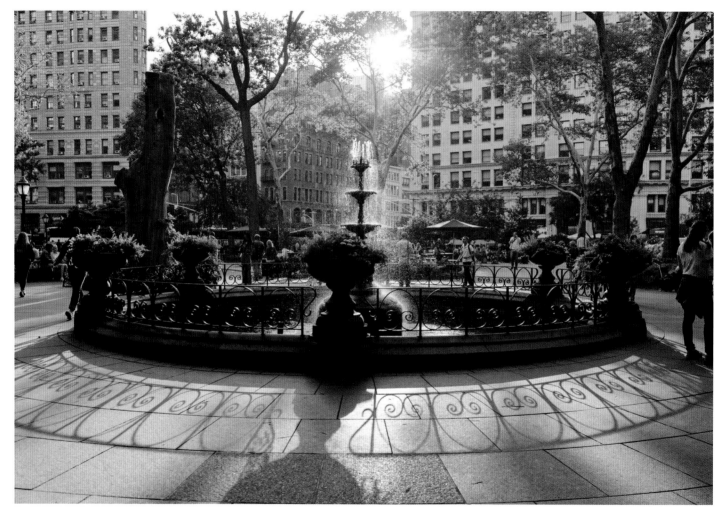

Madison Square Park in the Flatiron district hosts public art exhibits but, since 2004, most New Yorkers have known it as the site of the original Shake Shack burger stand, which still inspires epically long queues of fans of its burgers, hot dogs, frozen custard, shakes, beer, wine and more.

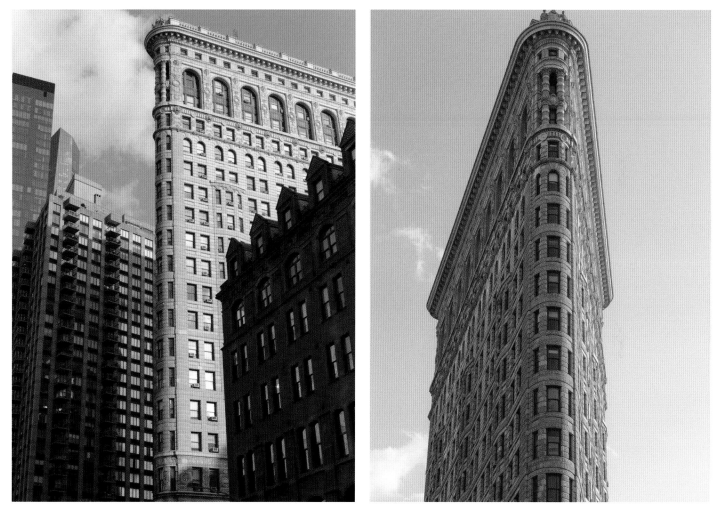

At 23rd St and Broadway, the elegant Flatiron Building is so famous that it lends its name to the surrounding district. The Macmillan publishing company has its US headquarters here. The offices at the point of the structure have perfectly framed views of the Empire State Building, farther uptown.

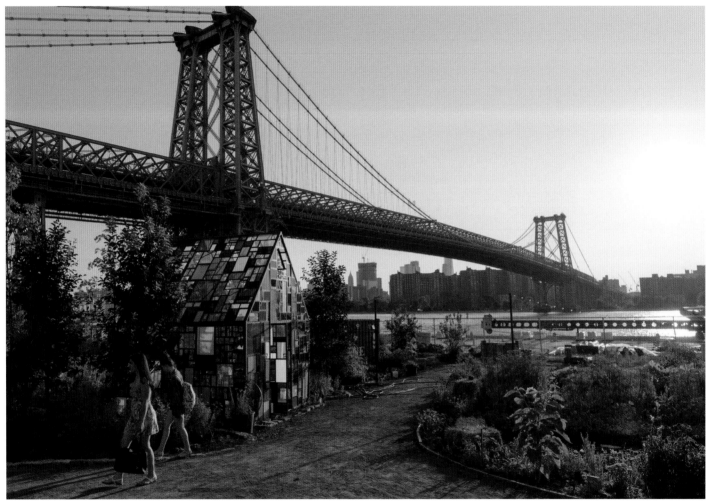

Kolonihavehus Sculpture by Brooklyn artist Tom Fruin

Waterfront land under the Williamsburg Bridge, formerly the site of the Domino Sugar Refinery, has been repurposed for healthier food. The Farm on Kent grows organic vegetables and teaches sustainable agriculture to greenery-deprived urbanites.

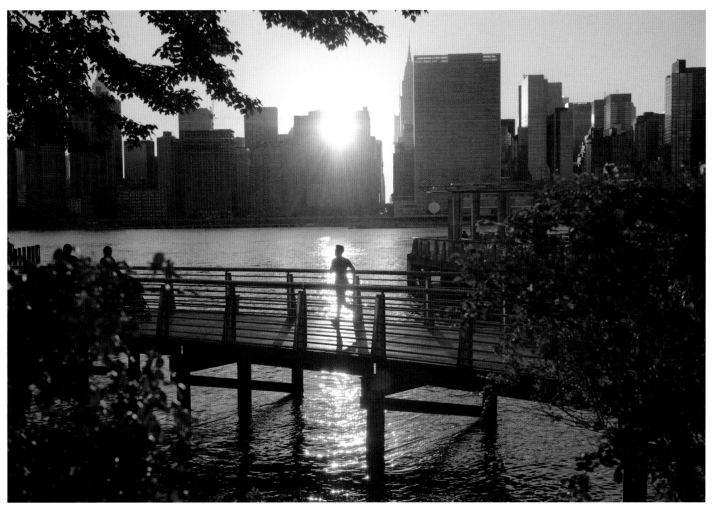

The expansion of NYC's riverfronts into parkland – here in Gantry Plaza State Park, Long Island City – has added more room for running and other after-work de-stressing activities. In 2007, the city set a goal that every New Yorker would live within 10 minutes' walk of a park, which is now the case for 76% of the population.

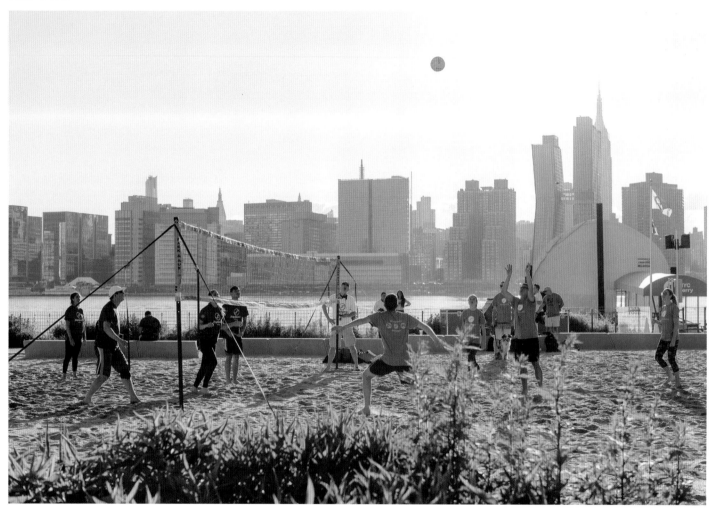

Hunter's Point South Park in Long Island City isn't exactly a beach, but it'll do for an afternoon volleyball game. Reclaimed from an abandoned post-industrial area, it's now a 10-acre (4 hectare) park offering breathtaking views of the Midtown East skyline.

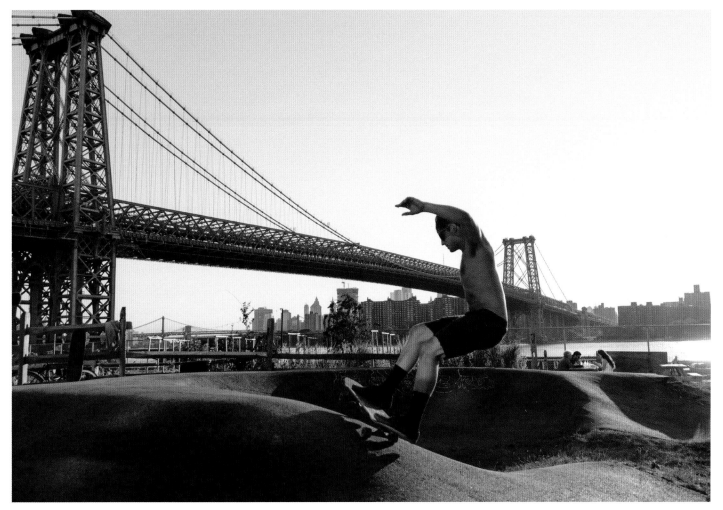

Down the East River and back under Williamsburg Bridge, a skate-and-bike park and a stained-glass greenhouse by artist Tom Fruin (who made his name with colourful quilts made of discarded plastic drug bags, and a stained-glass watertower on the rooftop of 20 Jay St) form typical Brooklyn scenery.

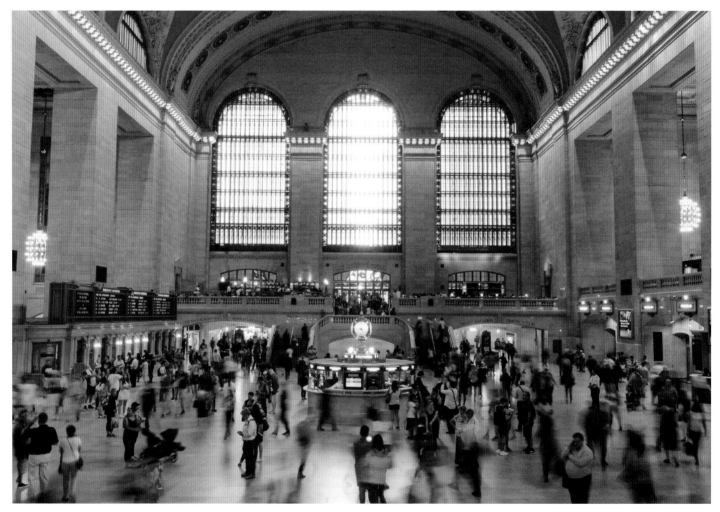

Grand Central Terminal, built in 1903, is a massive transit hub on the East Side. The cavernous main hall gradually became covered in grime – mostly tobacco smoke, tests revealed – until a 1996 renovation scrubbed it clean. A single dark patch was left untouched on the ceiling to remind visitors of the grime that once covered it.

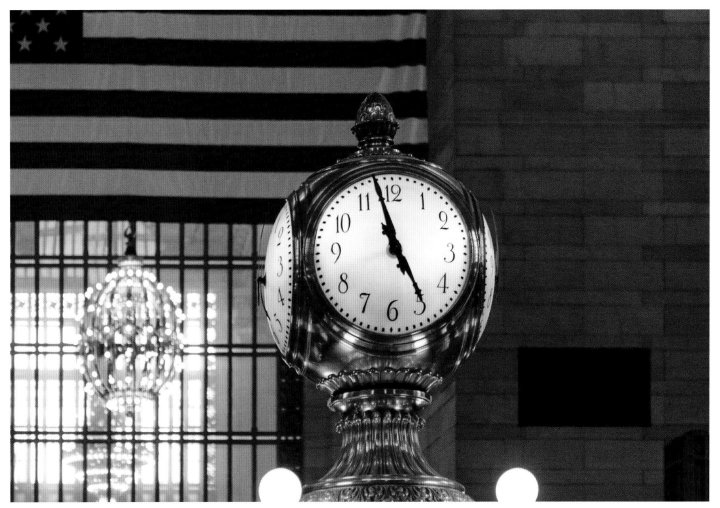

The clock above the information booth in the centre of Grand Central Terminal, designed by Henry Edward Bedford and cast in Waterbury, Connecticut, is a popular meeting spot in the middle of the rush.

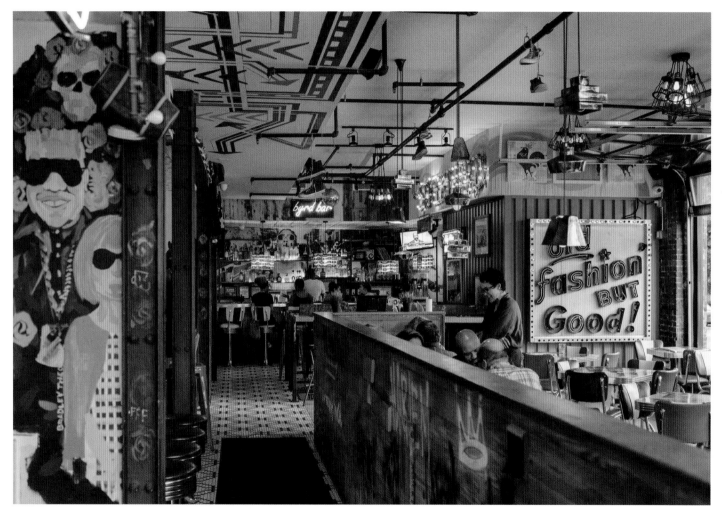

1900: Harlem is synonymous with NYC's African-American history and culture, but it has also become a destination for recent African immigrants. One slightly atypical example is Ethiopian-Swedish chef Marcus Samuelsson, whose Streetbird Rotisserie presents American soul food alongside flavours from Africa and Asia.

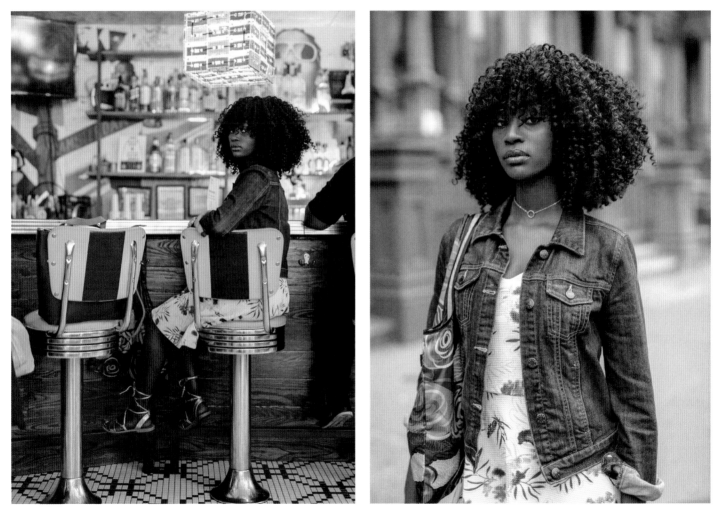

Streetbird reflects Harlem's current eclectic style. The neighbourhood remains strongly African-American, although longtime residents worry that it will lose its heritage as its prime brownstones are redeveloped and sold to new, non-black homeowners.

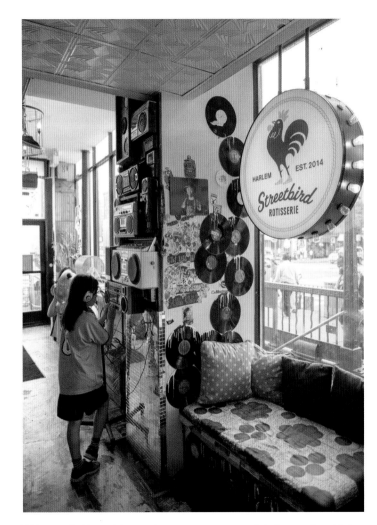

With its wall of boom boxes and creative cassette-tape light fixtures, Streetbird Rotisserie honours Harlem's role in early hip-hop culture.

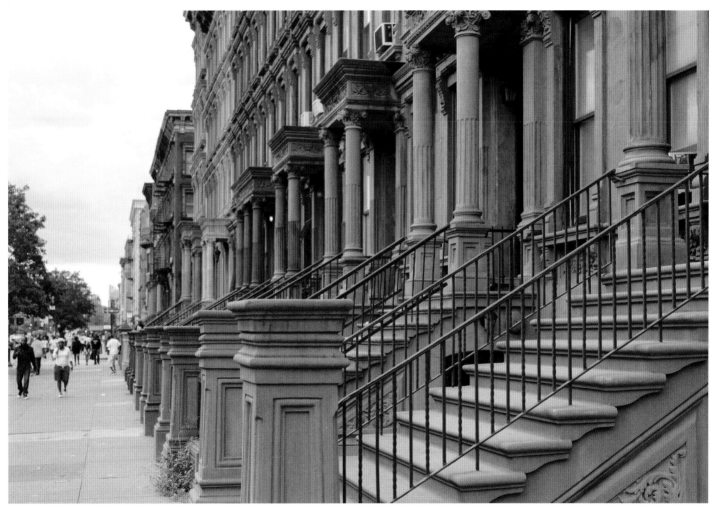

Harlem's brownstones are an architectural treasure. The building style was popular in the late 19th century, employing the signature brown sandstone and marked by tall stoops to keep the front door well above the level of the street and all its horse manure.

2000: This 'corner deli' in SoHo is more than meets the eye. It's a speedy taco joint, with an exclusive, hard-to-find brasserie hidden in the basement. The Mexican food may be new, but spinning a weird location into a prestigious asset is a trick Manhattan restaurateurs have been working for decades.

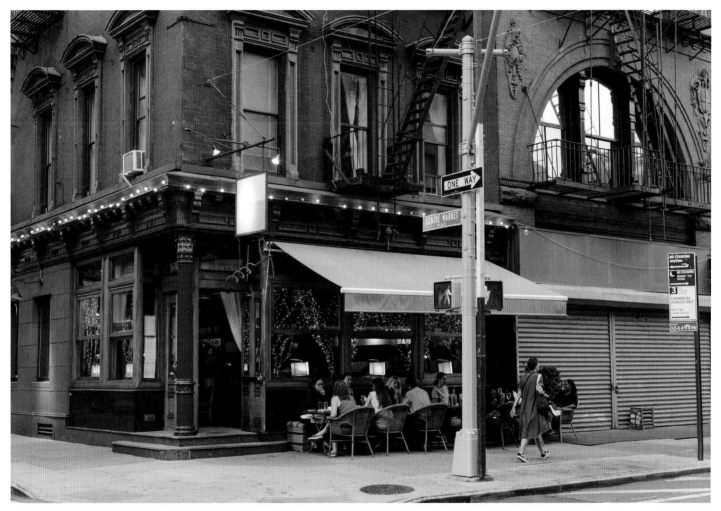

Never mind the Irish name, Onieal's sports red and green to reflect its prime position on the edge of Little Italy. It's a sedate neighbourhood bar, perhaps a legacy of its location across the street from the former NYC police headquarters.

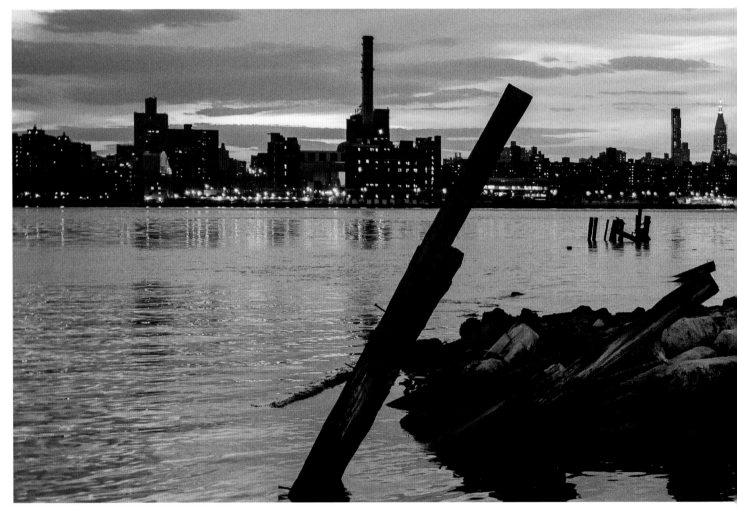

Ruined piers at Bushwick Inlet Park in Brooklyn are remnants of an era when New York City was more oriented towards the water, through trade and ship-building. Now, as the glowing lights of Manhattan attest, the energy is almost entirely on land.

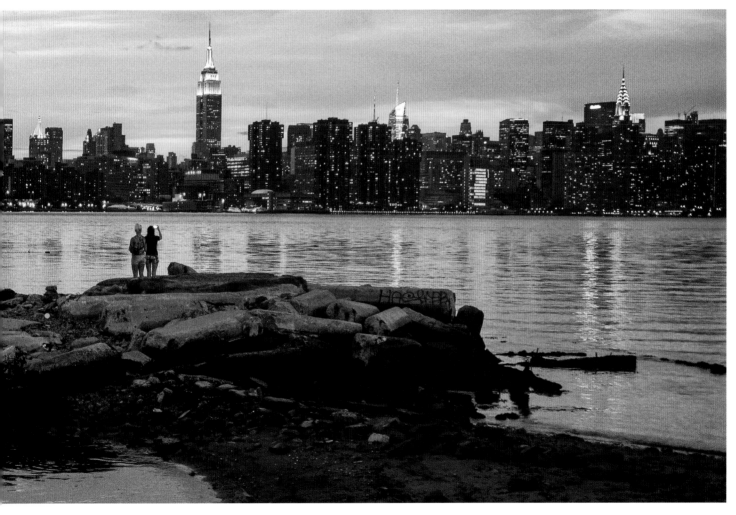

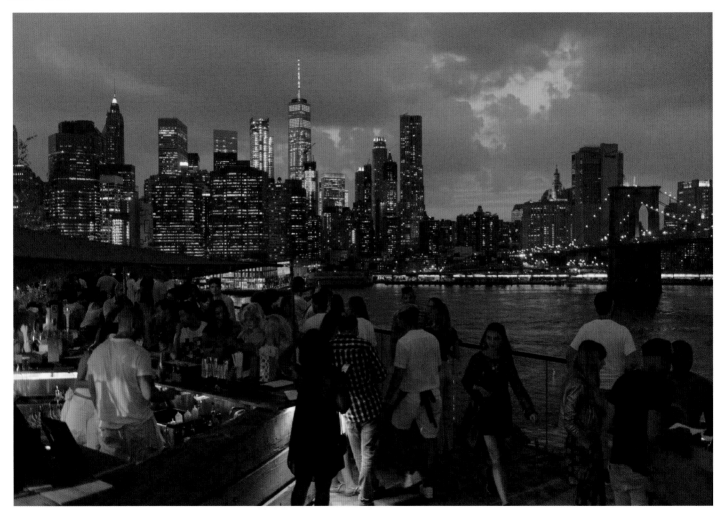

2100: Nightfall over Manhattan, as seen from Brooklyn Heights, is one of the most recognisable views of the city, enshrined in films and photos. The rooftop bar at 1 Hotel Brooklyn Bridge, opened in the park downhill from Brooklyn Heights in 2017, makes the vantage point even better, as it's closer to the river's edge.

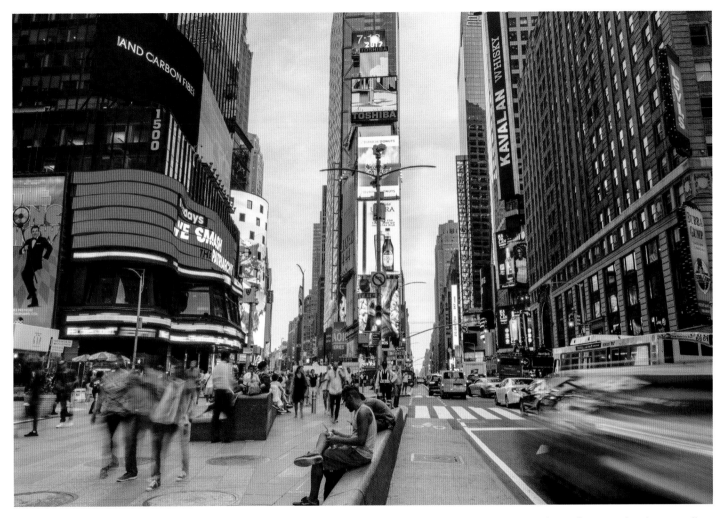

Times Square is sometimes called the 'bow-tie' for how Broadway cuts through diagonally. In 2009, the bow-tie was trimmed. Broadway was closed to car traffic and filled with plastic lounge chairs, creating the ultimate 'asphalt beach'. The pedestrian area has more formal furniture now, and plenty more foot traffic.

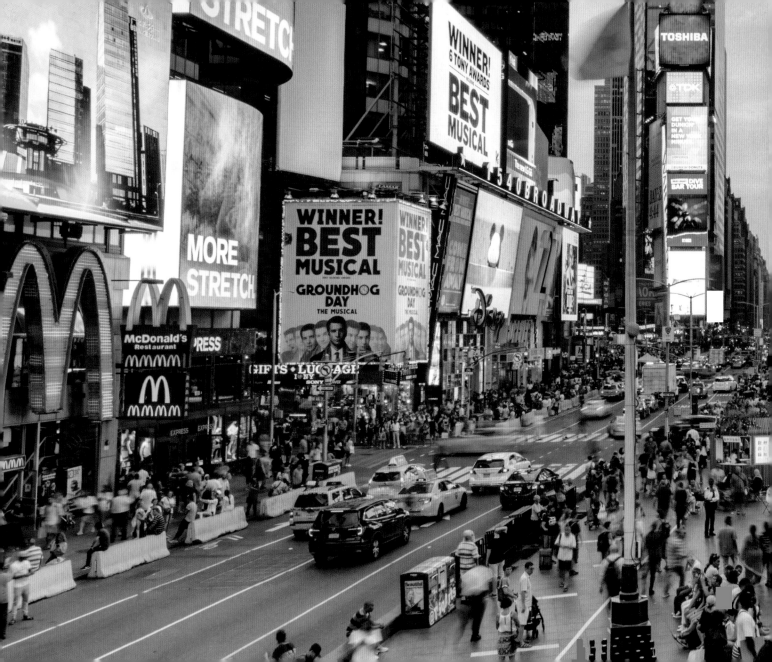

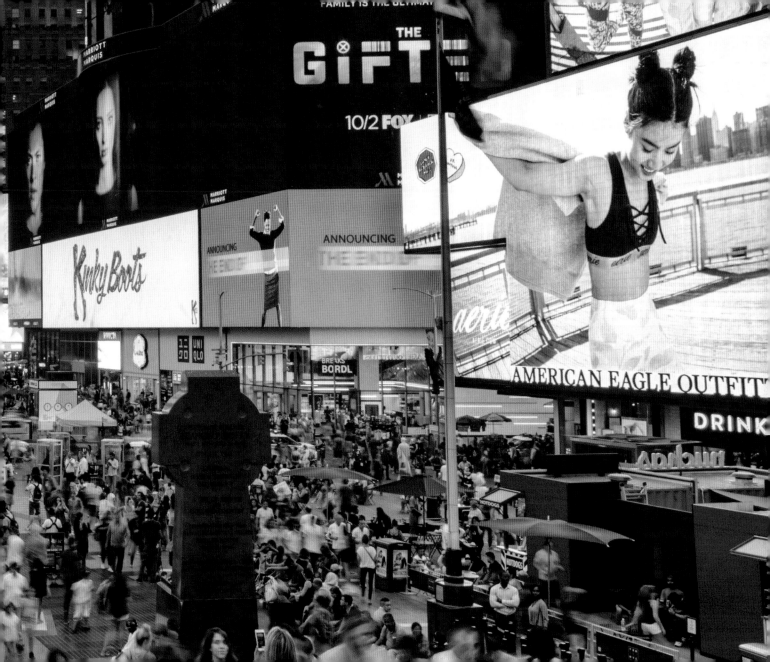

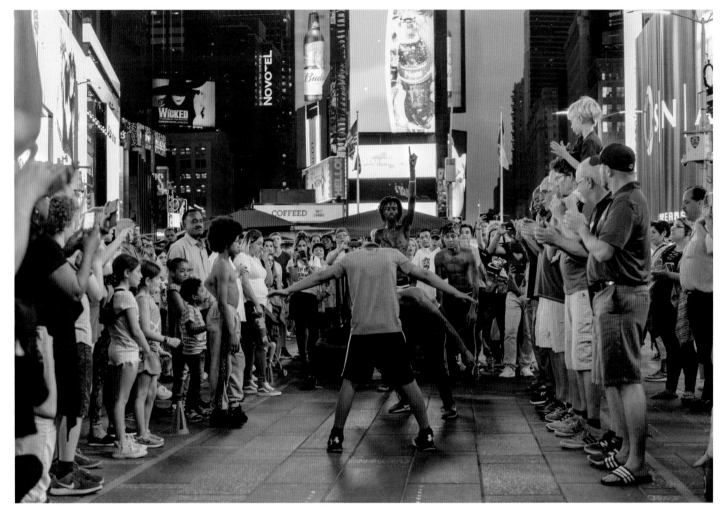

2200: At the heart of the historic theatre district, Times Square has become equally known for its street performance, due to the expansion of the pedestrian areas. Tourists flock here for a glimpse of self-made legends such as the Naked Cowboy, great dance teams and an endless parade of cartoon characters.

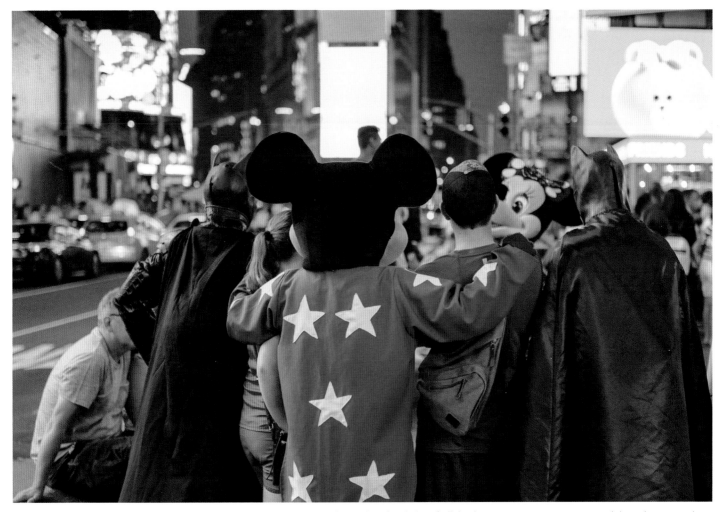

The Great White Way – the old term for Broadway around Times Square, due to the white lights of all the theatre marquees – is maintained through zoning rules that require buildings in the area to install large illuminated signage that casts a mesmerising glow over the traffic.

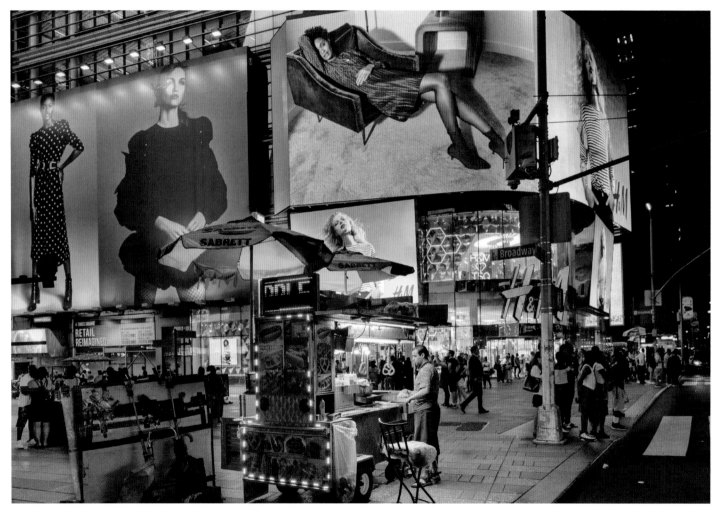

New York's reputation as the city that never sleeps was born in the glowing, all-night lights of Times Square. Food vendors dot corners, doling out pretzels and halal chicken and rice till the wee hours.

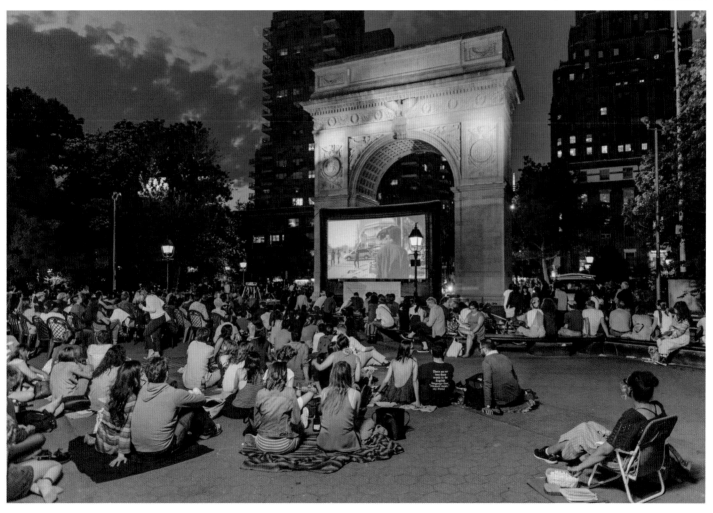

City residents who don't flee to the beach in the dog days of summer are rewarded with free culture in places like Washington Square Park, which hosts a movie series in front of the Washington Square Arch as well as concerts, theatre and a music festival.

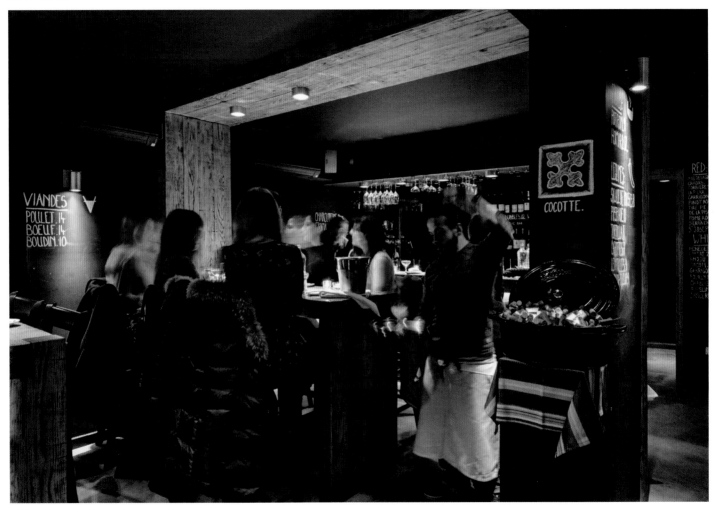

2300: Cocotte, a French-Spanish restaurant in SoHo, shows typical creative use of space. Facing exorbitant commercial rents, Manhattan restaurateurs often go for 'cozy' ambience and thus seat diners as snugly as does a subway train.

'Cocotte is one of the most romantic and charming restaurants in the city. It's a hidden gem in the heart of SoHo. Its interior is a mix of oak and charcoal walls with authentic tiles from the south of France. Chef-owner Sebastien Pourrat offers a menu with tastes from the Basque Country. My favourite dishes are his one-of-a-kind take on the burger for brunch or the boeuf with fingerling potatoes for dinner. I always get dessert, mostly the lemon tart made by Sofie, the pastry chef. She's the chef's wife and the reason for his transfer to New York, when she was a top model walking the runway for Chanel.'

- *Guillaume Gaudet*

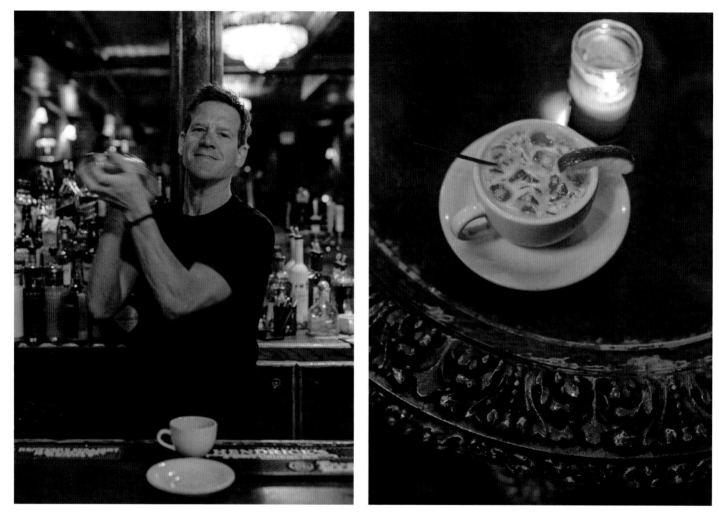

Drinks at the Back Room – a reopened original speakeasy on the Lower East Side – are served in teacups, just as they were during Prohibition, for plausible deniability when the police came knocking. On Monday nights, the bar hosts a live jazz band. As one of the bigger speakeasy bars, it has room for dancing.

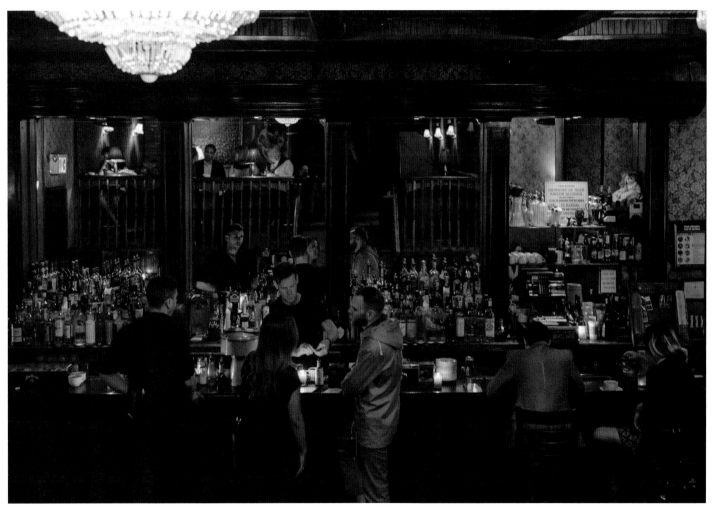

The first nouveau speakeasies, such as Milk & Honey (opened in 2000), revived the city's cocktail culture, rooted in pre-Prohibition times. These hidden bars with elegant surroundings and bartenders working meticulously on each drink have inspired more sedate night-time behaviour – and often sharper dressing.

2400: Night-time is the right time for a little colourful transformation. At House of Yes in Bushwick, New Yorkers can shake off all thoughts of their day jobs and slip into a more fabulous nocturnal persona.

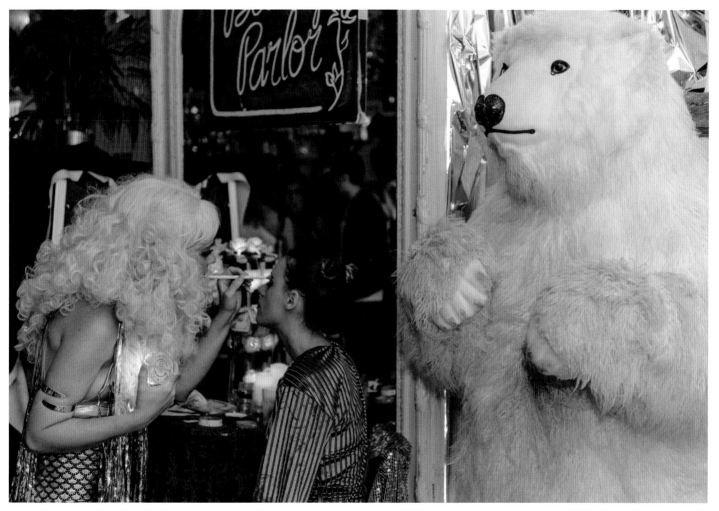

House of Yes, first opened in 2007, has a history typical of many New York establishments, being forced to move several times due to rent hikes and a fire. Along the way, however, it has morphed from a rough almost-squat to a fully professional venue.

Bars and clubs in New York City must stop serving alcohol at 4am. However, as long as you know where to look, you'll surely find an afterparty that will tide you over until the morning.

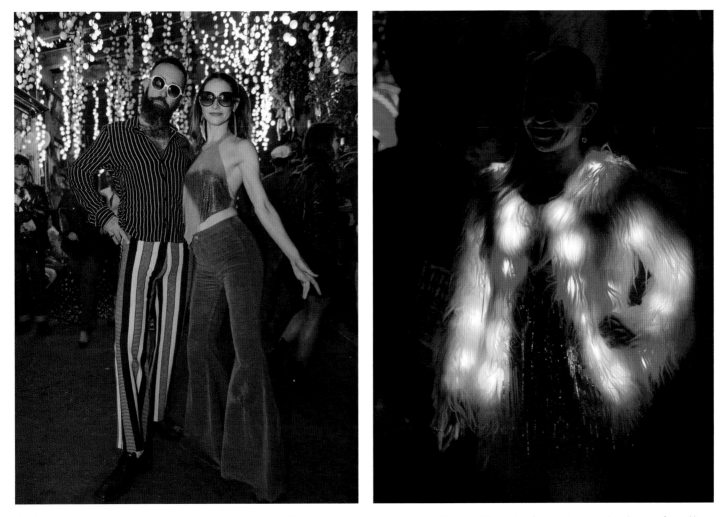

As Manhattan has become more expensive, much of New York City's more vivid and creative nightlife has shifted out to fringier, less populated parts of Brooklyn – such as Bushwick, around House of Yes, where there are fewer neighbours to file noise complaints.

House of Yes began as a creative collective, with circus performers, burlesque dancers, filmmakers and musicians contributing to parties. Although it operates in a more organised, better-funded space now, it maintains its cooperative, anything-goes vibe. It's a line nearly every creative business in the city has to walk.

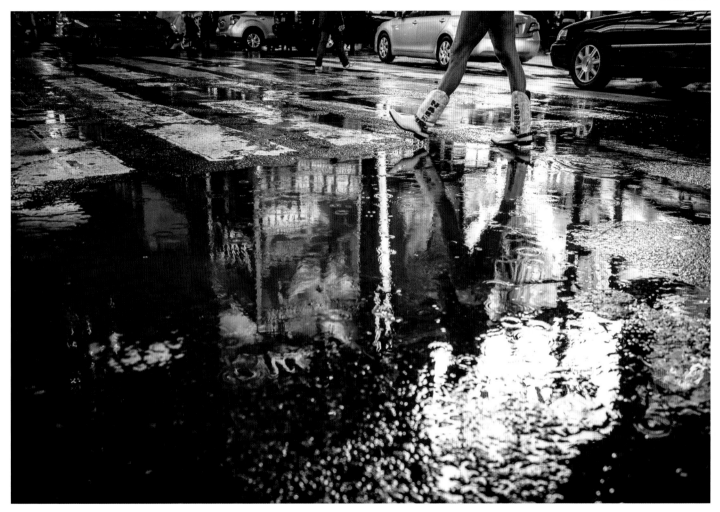

Even New Yorkers have to call it a night at some point, making their way home via subway train, yellow taxicab or perhaps choosing to tackle the neon-splashed streets on foot, savouring the pre-dawn hours when the city is still very much abuzz.

Published in May 2018 by Lonely Planet Global Limited
CRN 554153
www.lonelyplanet.com
ISBN 978 1 7870 1344 5
ISBN (US) 978 1 7870 1812 9
© Lonely Planet 2017
Printed in China
10 9 8 7 6 5 4 3 2 1

Publishing Director Piers Pickard
Associate Publisher & Commissioning Editor Robin Barton
Art Director Daniel Di Paolo
Photographer Guillaume Guadet
Writer Zora O'Neill
Editors Yolanda Zappaterra, Nick Mee
Print Production Larissa Frost, Nigel Longuet
Thanks to Flora Macqueen

STAY IN TOUCH lonelyplanet.com/contact

AUSTRALIA The Malt Store, Level 3, 551 Swanston St,
Carlton, Victoria 3053 T: 03 8379 8000

IRELAND Digital Depot, Roe Lane (off Thomas St),
Digital Hub, Dublin 8, D08 TCV4

USA 124 Linden St, Oakland, CA 94607
T: 510 250 6400

UNITED KINGDOM 240 Blackfriars Rd, London SE1 8NW
T: 020 3771 5100

Although the authors and Lonely Planet have taken all reasonable care in preparing this book, we make no warranty about the accuracy or completeness of its content and, to the maximum extent permitted, disclaim all liability from its use.

Paper in this book is certified against the Forest Stewardship Council™ standards. FSC™ promotes environmentally responsible, socially beneficial and economically viable management of the world's forests.